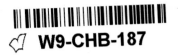

ASPEN

*Portrait
of a
Rocky Mountain
Town*

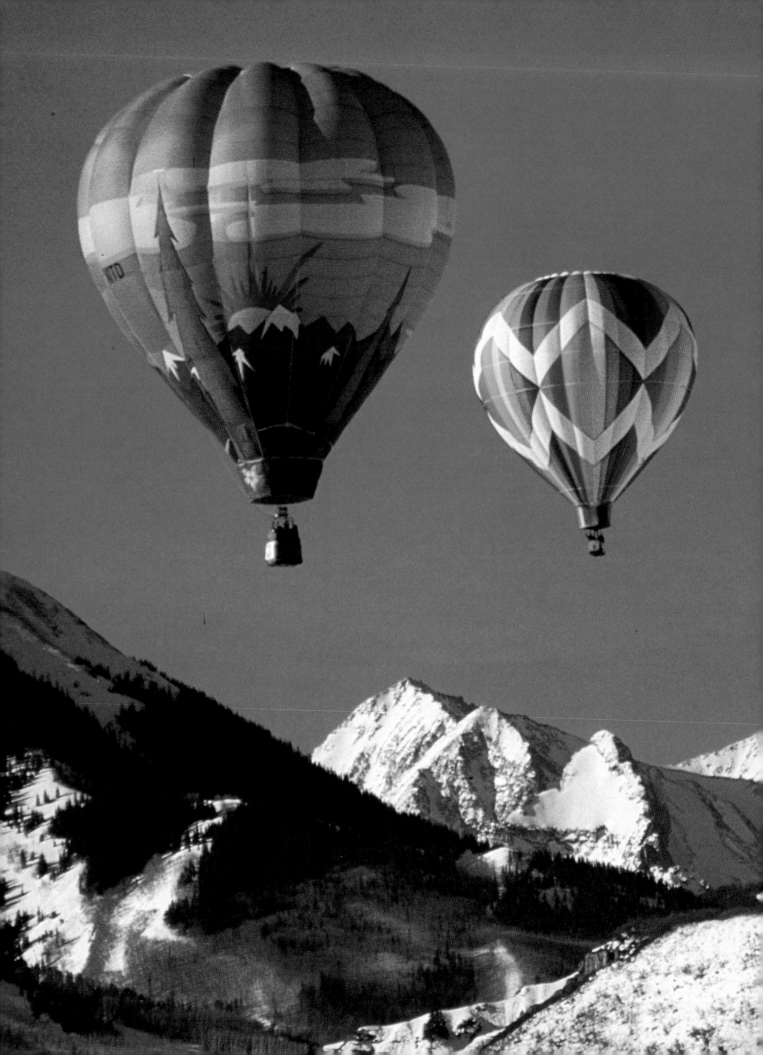

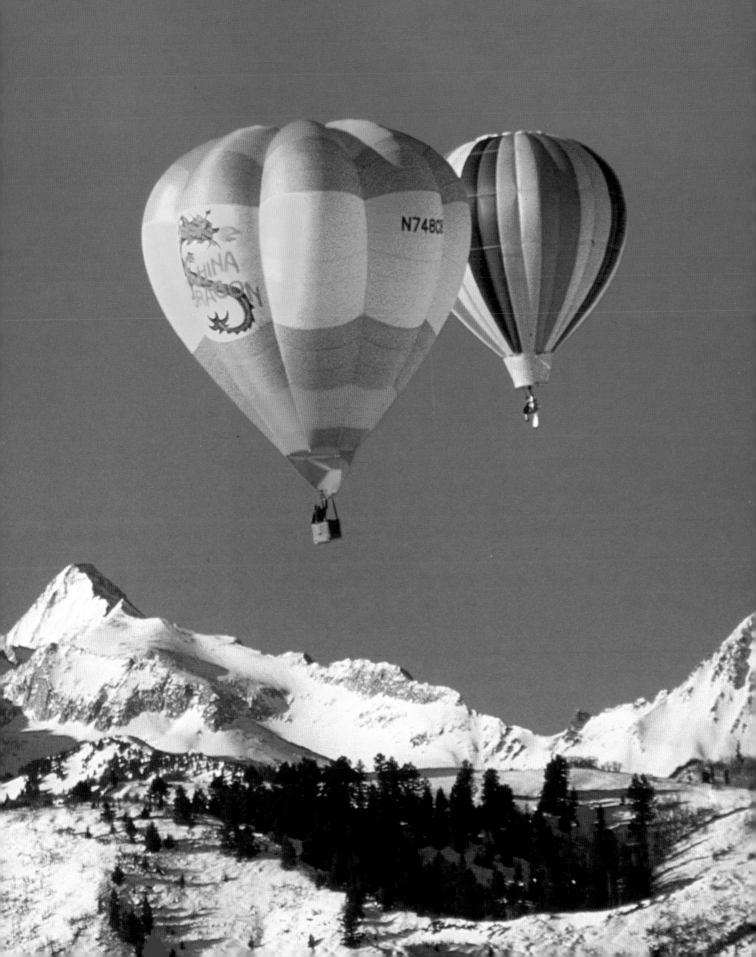

ASPEN

*Portrait
of a
Rocky Mountain
Town*

PHOTOGRAPHERS/ASPEN

Paul Chesley

Nicholas DeVore III

David Hiser

WRITTEN BY

Paul Andersen

PUBLISHED BY

Who Press

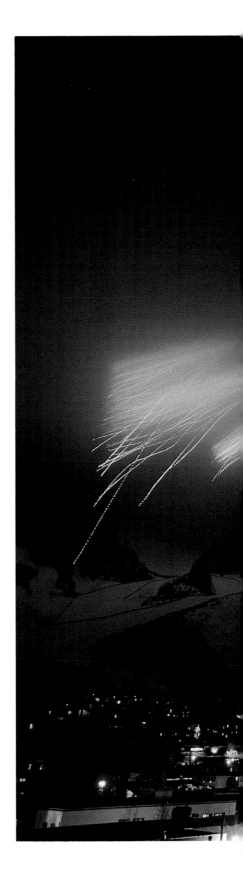

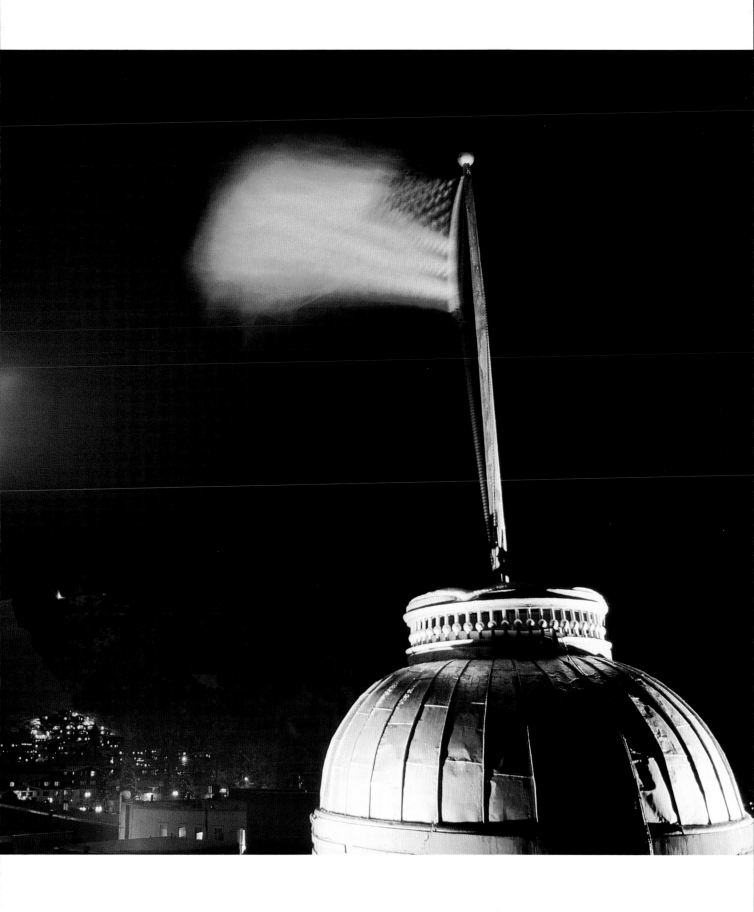

PAGE 1 *An old Forest Service sign in the Hunter Creek Valley directs the way to Aspen.*

PAGES 2 & 3 *As if dipped in red paint, a small grove of aspen trees in its final surrender to the change of the seasons highlights an autumn day.*

PAGES 4 & 5 *In the stillness of a winter morning hot air balloons rise into the crisp air against a blue-sky day over Snowmass Village.*

PAGES 6 & 7 *Sunset over the Williams Mountains at the head of Hunter Creek gives meaning to the term "alpenglow."*

TITLE PAGE *The rockets' glare lights Aspen's night sky as the stars and stripes fly from the illuminated dome of the century-old Elks' Building in downtown Aspen.*

Copyright © 1992 by Warren H. Ohlrich

PUBLISHED BY

WHO PRESS
Post Office Box 1920 • Aspen, Colorado 81612

Library of Congress Catalog Card Number: 92-90947
ISBN 0-9620046-8-5

Photographs by Photographers/Aspen
Text by Paul Andersen
Edited by Warren H. Ohlrich
Design & Production by Curt Carpenter
Typeset in Bembo by Bland Nesbit

PHOTOGRAPHIC CREDITS
Paul Chesley pp. 2, 9, 13, 15, 21, 31 bottom, 41 bottom, 46, 49, 51 top, 72-73,
88 bottom, 89-90, 92, 94, 96 top, 98 upper left, 99, 101
Nicholas DeVore III pp. 1, 4, 22-27, 39, 40 top, 42, 50, 52-56, 57 top, 58-61, 63, 71,
82-83, 86, 91, 93, 96 bottom, 97, 98 upper right, 98 lower left, 100, 105 top, 108
David Hiser pp. 6, 12, 16-19, 28-30, 31 top, 32-38, 41, 43-45, 48, 51 bottom, 62,
64-70, 74-81, 84-85, 88 top, 95, 98 lower right, 102-4, 105 bottom, 106
Jonathan Wright p. 57 bottom

PRINTED BY MOUNTAIN WEST PRINTING, LTD., DENVER, COLORADO
COLOR SEPARATIONS BY UNIVERSAL GRAPHICS, BOULDER, COLORADO

Contents

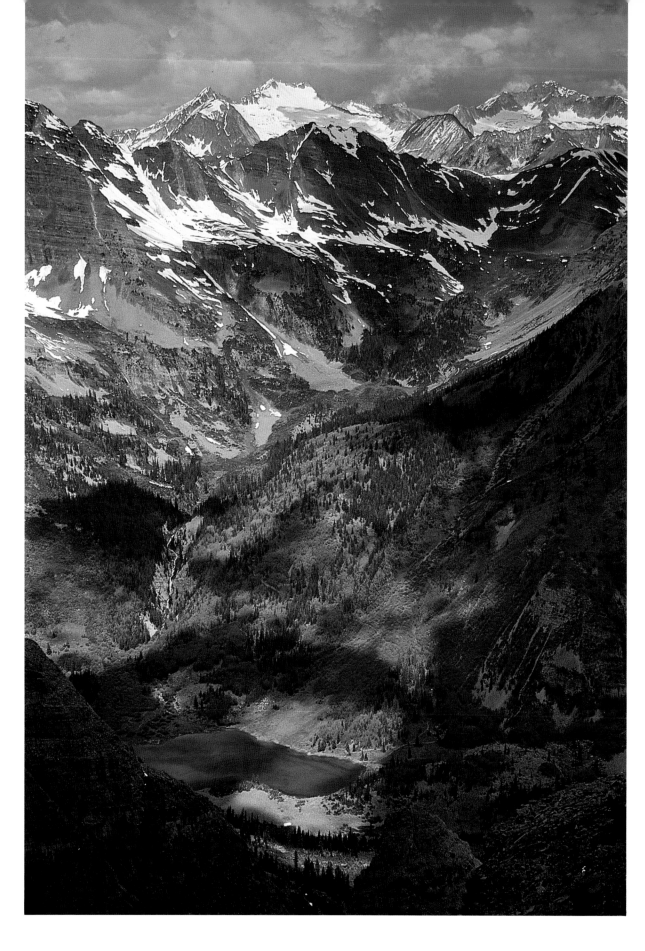

Introduction

Piecing together the Aspen picture requires perspective and patience. The mosaics are diverse and multi-colored, and they don't always fit squarely and conveniently together. The dichotomy is represented by a neat, orderly grid of streets bordered by random wilderness, by a blending of distinct historic time lines, by the warp and weave of a uniquely divergent social fabric. Add a vital flirtation with fantasy and Aspen becomes one of the most unusual social experiences within the great American landscape.

Aspen is a city founded on mining, reborn on ideals and propelled into the future by commercial enterprise. Through it all, Aspen has been a fruitful ground for believers, whether a New York capitalist investing in a silver mine, a Chicago industrialist inspired by a utopian vision, an artist striving to master the depths of personal expression, or a seeker who thinks that life is better at 8,000 feet in the Central Rockies of Colorado than in urban Los Angeles, Houston, Chicago or New York.

Today's Aspen is an amalgam of all its parts. Mining still exists as a maverick pursuit on century-old claims. Ideals flavor the community with a residual reverence of what can be from Walter Paepcke, Albert Schweitzer and others who sowed the seeds of appreciation for the intellect and the arts. Commercialism flourishes with lavish hotels, ritzy boutiques, high-end art galleries and the best restaurants between Chicago and San Francisco.

Putting Aspen together, piece by piece, an image emerges from the jigsaw puzzle that bears close scrutiny. Aspen demands a weighing of values, the tallying of amenities and finally, a personal judgment. Anyone familiar with the community cannot help but interpret and evaluate its effect. The pieces of the picture may not stack up evenly, but they represent a portrait painted by the genius of circumstances where man and nature continue the struggle for rapport.

LEFT *Looking into the heart of the Maroon Bells–Snowmass Wilderness lies Maroon Lake, Buckskin Pass and in the distance, Snowmass Mountain (left) and Capitol Peak (right).*

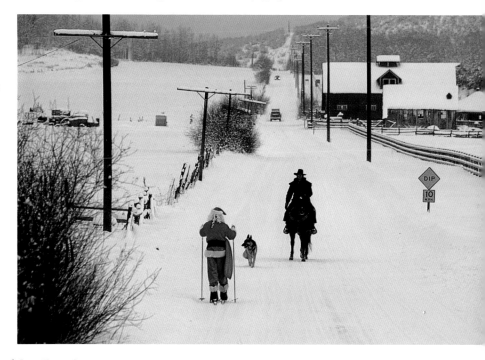

ABOVE *Late afternoon, December 24th on Owl Creek Road, Santa gets a little fresh air before his evening's work.*

1 Silver Mining

Aspen's beginnings as a mining bonanza can be traced to Independence Day, July 4, 1879, when two prospectors from Leadville made a gold strike in a remote, high alpine basin near the Continental Divide. They named their claim Independence in honor of the holiday and introduced mining to the headwaters of a pristine valley where the river flowed with such force that it was named the Roaring Fork.

Miners came on foot, on skis, with mule teams and sledges, cresting Independence Pass from the booming mining camp of Leadville. These fortune hunters were driven by a sense of adventure and the thrill of discovering riches. Their promise was the all-consuming motivation of wealth.

But the Roaring Fork Valley, a wilderness and the former domain of the Ute Indians, held considerable risk. Indian raids and the harsh demands of high-altitude living were constant threats. Avalanches, forest fires, mine disasters, all took their toll. But the silver that had made men rich in Leadville was a strong incentive for a new settlement in a broad valley 20 miles below the Independence townsite where the canyon widened and the river's roar became a murmur. They called the camp Ute City and later Aspen, for the ubiquitous trees covering the valley floor.

The prospectors laid out their surveyed rectangles—1,500 feet by 300 feet—for patent under the Mining Law of 1872, and with pick, shovel and dynamite turned Aspen into a cornucopia of wealth. At the height of Aspen's glory in the 1890s, the population swelled to 12,000; the thriving city boasted a grandiose opera house, several first-class hotels, two railroads, a horse track and hydropowered electricity that illuminated street lights. At peak production in 1893, Aspen's 270 mines produced over $6 million worth of silver annually. Commerce was conducted by two railroads, the Denver & Rio Grande Western and the Colorado Midland, which raced to blast and tunnel their way into the valley by 1887. The D&RGW bested the Midland by only 60 days.

Aspen was the talk of mining camps throughout the West and her glory spread to investment houses on Wall Street. Aspen's mother lode was the Molly Gibson Mine, renowned as the richest silver mine in the world. Attesting to the earth's bounty, the Smuggler Mine, in 1894, produced the largest silver nugget ever found. Pared down to 1,840 pounds, so it could be carried from the shaft, the nugget was 93% pure silver. A magnificent trophy, it was paraded through Aspen on an open wagon drawn by mules.

In the early 1890s Aspen's work force of 2,500 miners slaved for an average wage of three dollars a day, a stipend that had laborers flocking to

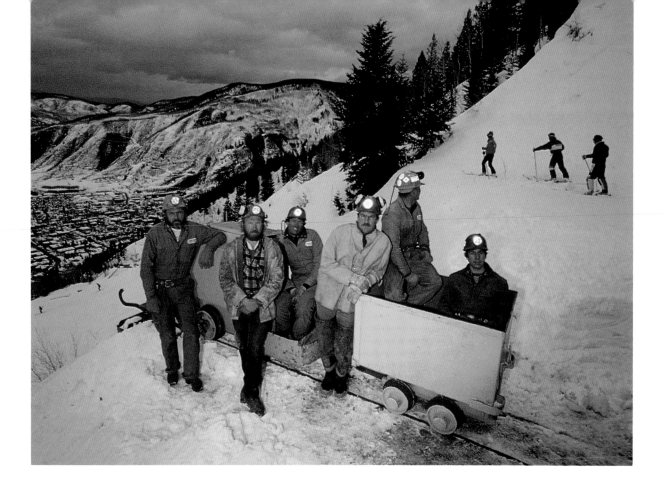

the mines with reckless hope. They found succor in brothels and bars while risking life and limb in one of the most dangerous of all professions.

When the U.S. Treasury shifted from silver to gold as the standard for currency in 1893, Aspen's boom turned to bust. In an effort to promote "free silver," Aspen sent a gem-encrusted silver statue of a woman in a chariot—The Silver Queen—to the Chicago Exposition of 1893. But the gesture failed to rouse support. The Silver Queen mysteriously vanished and Aspen was forgotten.

In the crash that followed, mines ceased their operations, businesses closed, fortunes were lost. Victorian homes were boarded up, with some dismantled for firewood. One of the most prosperous cities in the West faded into obscurity. By the 1960s both railroads had pulled up their tracks and abandoned the one-time bonanza.

But the mining days left an indelible imprint. The Rio Grande rail line exists today as a popular trail and there are schemes to reintroduce rail service on its right-of-way. The Maroon Creek Bridge, a 100-year-old relic from the Colorado Midland Railroad, now carries State Highway 82 and thousands of automobiles a day. The "Dumps," popular ski runs on Aspen Mountain, are named for the mine dumps over which skiers carve turns through deep powder snow. Tiehack Ski Area got its name from the "tie-hackers" who cut timber for railroad ties on its slopes. Torchlight ski parades revive the vision of miners with lanterns marching to and from work on the night shift. The names of old mines—Silver Bell, Little Annie,

ABOVE *Contemporary miners work a silver mining claim at the top of the Little Nell ski run on Aspen Mountain while skiers glide by on groomed slopes. Mining claims from the 1880s are noticeable throughout the region.*

Galena, Spar—have been adopted for ski runs, restaurants and city streets.

The mining tradition is kept alive today by a new generation of Aspen miners who have accumulated claims, reopened shafts and explored a honeycombed world hewn from solid rock a century ago. Today's Aspen miners do much of their prospecting in the county courthouse, digging through dusty records to acquire ownership of historic mining claims. A black marble quarry on Conundrum Creek, within the boundaries of a designated wilderness area, has focused attention on a national debate for mining law reform. An alabaster mine in the Crystal Valley and hundreds of mine claims proposed for real estate development have fueled local land use controversies.

Aspen has been listed as an EPA Superfund site because of high concentrations of lead at a century-old mine dump within the city. Derelict mines dotting the backcountry contribute to ground water pollution and are blemishes on the landscape. Open mine shafts remain a hazard, one claiming the life of a young skier in 1986 on Aspen Mountain. The romantic legacy of mining is anything but benign.

The blending of past and present is most conspicuous where the Aspen Mining Company is working an active claim at the top of the Little Nell ski run on Aspen Mountain. A handful of today's miners explore underground for silver, while above ground, skiers ply groomed slopes and are whisked up the mountain on state-of-the-art ski lifts. The time line blurs as history repeats itself.

BELOW *A wagonload of black marble is hauled down the Conundrum Creek road by means of historic horsepower, but with a future intent for mechanized mining.*

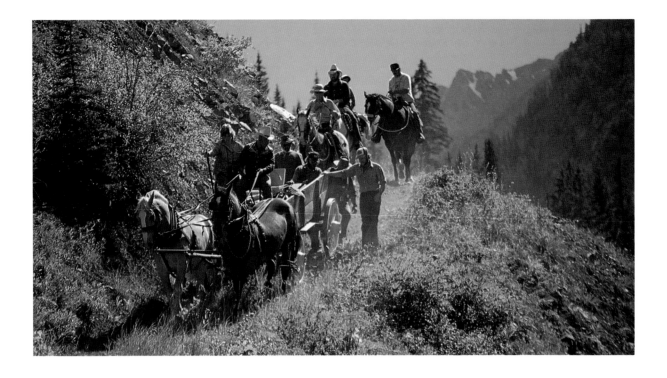

2 Ghost Towns

A faint trail climbs from the Hunter Creek valley up a steep mountainside through aspen groves and occasional stands of spruce. It curves and bends with the contours of the land, disappearing here, emerging there. Gaining the top of the ridge, the trail passes a mound of dark gray mine tailings and promptly ends at the ruins of a log cabin.

The cabin walls are broken and decayed and the roof has disappeared. The remnants of a cook stove, rusted and broken, are strewn about. And a young aspen tree sprouts from the rotted floor. The cabin represents a grubstake, a prospect that never panned out. It tells a story repeated a thousand times in the West.

Outlying Aspen like satellites, mining ghost towns are testaments to a brief era of prosperity. Progressing from tent cities to log cabins and later to rows of rough-cut, clapboard buildings, these towns swelled with ranks of itinerant, hard-living miners and the profiteers who followed them.

In Ashcroft, 11 miles south of Aspen at the base of two rugged mountain passes, Express Creek and Pearl Pass, 100-year-old buildings stand on either side of a grassy street. Their false, wooden fronts are dark from weathering and reveal an illusory effort to inflate reality. False fronts, like false promises, are proof that substance cannot be achieved through artifice. Today Ashcroft is a ghost town where a sagging boardwalk bears the tread of an occasional visitor gazing at this three-dimensional history book.

Set like a gem in a subalpine valley at 9,500 feet, Ashcroft, first named Chloride, was established about the time of Aspen and boasted a population of 2,500 ardent miners who worked Horace Tabor's Tam O'Shanter and Montezuma mines for silver. Baby Doe, Tabor's young bride, is said to have visited Ashcroft, setting off a 24-hour celebration with an open bar for the entire camp, compliments of Tabor. With a fleeting but lusty life, Ashcroft lived hard for less than 20 years.

During World War II a detachment of the Tenth Mountain Division ski troops was stationed temporarily in Ashcroft during the construction of Camp Hale near Leadville. In 1948 Stuart Mace received a lifetime lease on one acre of land, brought his dog teams from the Tenth Mountain Division and built Toklat, his home. In the 1950s, Mace and his dogs were filmed for the TV series "Sergeant Preston of the Yukon" in the mountains surrounding Ashcroft. In 1975 the town was designated a National Historic Site and is today a thriving cross-country ski area.

In the town of Independence, high above Aspen at 10,880 feet, miners worked their claims in harsh conditions, battling the deep snows

ABOVE *Weathered wood and weathered bones convey a palpable sense of time in the ghost town of Ashcroft, where relics of a people and a place evoke a fascination in history.*

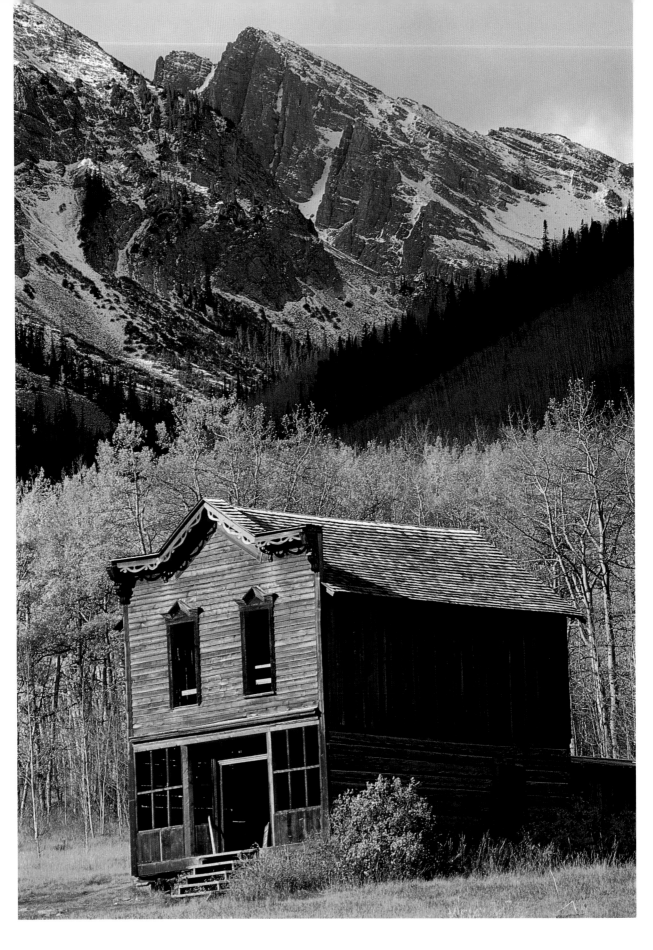

and excessively cold temperatures of high elevation. Established July 4, 1879, and named for Independence Day, the camp enjoyed early prominence from the gold found there. The fledgling town depended for commerce on the Kit Carson Stage Line, which provided goods and services on its run between Leadville and Aspen over Independence Pass.

By 1881 Independence had four grocery stores, three saloons and four boarding houses. Less than a decade later, bowing to Aspen's growing prominence, it had become a ghost town. Today the scenic Independence Pass road bisects what's left of the old town.

The townsite of Ruby, a scattered collection of buildings near the head of Lincoln Creek less than 20 miles from Aspen, shows to what length miners would go in search of minerals. Far from any rail line or commerce center, Ruby was a wilderness outpost among high, windswept peaks. In its desolation today, Ruby is hushed and quiet. The wind blows unfettered through broken walls, open doorways and vacant windows.

Lenado, at 8,600 feet, was to be linked to nearby Aspen in the 1890s through a long tunnel cut beneath the Hunter Creek valley by H. P. Cowenhoven, a Prussian immigrant. But the grandiose scheme never came to fruition. Scattered buildings in what is now a wildflower meadow, Lenado was a logging camp that furnished mining timbers for Aspen. Today, a number of the old dwellings have been refurbished to house a small but hearty community that prefers the seclusion of the narrow valley to the hustle and bustle of Aspen.

The rough and tumble mining camps of the 1880s were mostly short-lived, utilitarian communities. Their citizens gathered to exploit the riches of the earth—and often each other. Their populations rose and fell with the promise of a strike or the news of a bust. But the devaluation of silver in 1893 proved more daunting than any adversity nature could dish out and ghost towns were made permanent by a decree from Washington, D.C.

FACING PAGE *Ashcroft, at 9,500 feet in the Castle Creek Valley, is humbled by towering mountain peaks from which mineral riches were extracted in Horace Tabor's mines. In the early days of the 1880s, Ashcroft eclipsed Aspen as the mining center of the Roaring Fork Valley.*

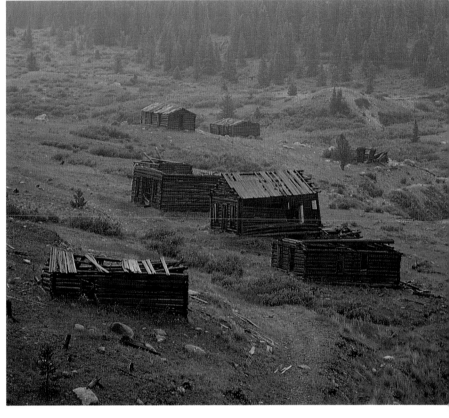

ABOVE *The townsite of Independence, at 10,880 feet, was named for a gold strike made on Independence Day, July 4, 1879, by two prospectors from Leadville. Today the Independence Pass road bisects the remnants of a once flourishing mining camp.*

3 Wheeler Opera House

Buildings often parallel the course of a community, and none reflect the fluctuating status of Aspen better than the Wheeler Opera House. Built in 1889 when Aspen had a population of 8,000 and rich silver mines were producing high quality ore, the Wheeler Opera House was an affirmation of Aspen's arrival as a city of substance.

Jerome B. Wheeler, who had come to Aspen five years earlier from New York, had determined that Aspen must acknowledge the arts if it was to become a full-fledged city of lasting prominence. He also needed a suitable and conspicuous location for the Aspen bank he had started. The building would be made to last, with construction of brick and peachblow sandstone from a quarry eight miles from Basalt on the Fryingpan River.

At the time Wheeler embarked on the ambitious plans for his opera house, Aspen had several theatres, a part-time roller skating rink and numerous taverns. But there was nothing like the Wheeler, which the local newspapers boasted would be second in Colorado only to the Tabor Grand in Denver. Both were designed by the same architect, W. J. Edbrooke.

Touring stock companies from New York traveled the "silver circuit," performing in any western mining community large enough to have a railroad depot, a theatre house and a population that would pay for a show. Most of the shows were comedies, musicals and melodramas, well-suited to an audience hungry for popular entertainment. Wheeler wanted the opera house to raise the ante for Aspen's well-heeled, culture-seeking residents.

The opera house was completed in 1889 and Wheeler opened his bank on the first floor, revealing plush furnishings and finish work that outshone anything in town. The grand opening of the opera house surpassed any production Aspen had ever seen and featured the comic opera, "King's Fool." Programs were printed on scented satin and the ladies received a complimentary bottle of perfume. The city was jammed with visitors who flocked to the Wheeler from coast to coast to experience its splendor. They were not disappointed.

Gilt boxes, leather upholstered seats, a domed ceiling studded with stars and a huge chandelier cast a golden aura over Aspen and typified the vision of stature this burgeoning silver camp had attained through benefactors like Wheeler. Eight dressing rooms, a special drop curtain painted by two New York artists, fifteen sets of scenery, and modern lighting made the Wheeler Opera House a treasured work of art that enjoyed a stellar, if fleeting, career.

Only five years after its opening, when Aspen was hit by the silver

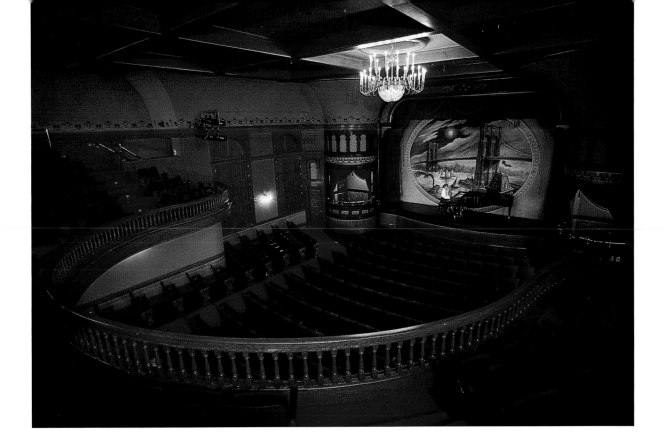

crash of 1893, the Wheeler lost its luster and became a tarnished piece of history. An anachronism of gilt and luxury in a broken city, the opera house stood vacant and hushed, forsaken by its audience and the stock companies that had brought it to life.

Jerome B. Wheeler was forced into bankruptcy and his Aspen holdings were lost. Two fires suspected as arson gutted the interior of the opera house in 1912 and destroyed part of Aspen's soul. The flames devoured a tangible aspect of the Aspen dream.

The building sat in disrepair for nearly 40 years while the Aspen economy gradually changed from mining to tourism. The opera house reopened in 1947 during the Fishing Festival of May and, despite its scorched walls, the Wheeler featured a performance given by Burl Ives. In 1949 the Wheeler was purchased by Walter and Elizabeth Paepcke, who hired Bauhaus architect Herbert Bayer to restore it. The first official lecture of Paepcke's Aspen Institute for Humanistic Studies was given at the Wheeler in 1950.

Another major restoration of the building's exterior was completed in 1974, and a substantial addition and costly interior renovation were completed by the City of Aspen in 1984, bringing the Wheeler back into prominence as a performing arts center, complete with gilt stars on the ceiling illuminated by a magnificent chandelier.

Today the Wheeler is renowned as much for its historical value as for the performances given there. Its stage is the top venue in town and features community theatre, films, dance, comedy, lectures and musical performances, from Classical to rock.

ABOVE *The interior of the Wheeler Opera House reflects the painstaking efforts that went into its restoration.*

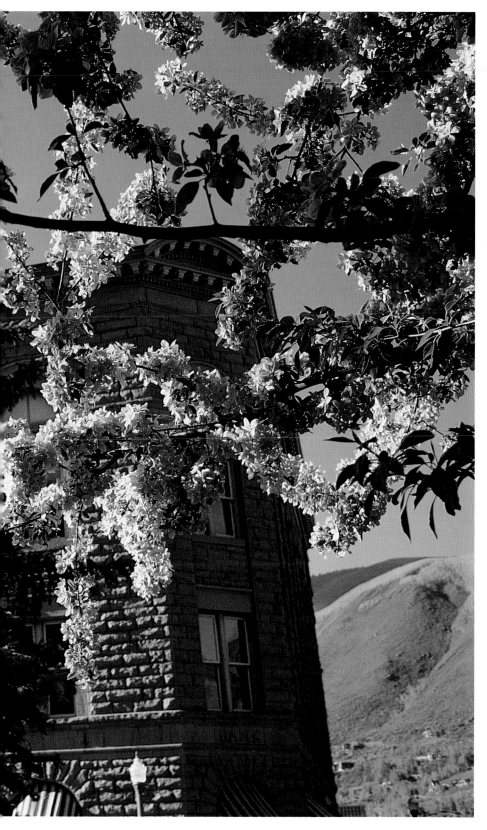

The Wheeler Opera House, one of Aspen's historic landmarks, was built to last of brick and peachblow sandstone quarried on the Fryingpan River. The building was an elegant tribute to Jerome B. Wheeler, one of Aspen's greatest benefactors. Its grand opening in 1889 measured up to expectations as one of the premier events in the town's history. Today the Wheeler remains a prominent center of performance art.

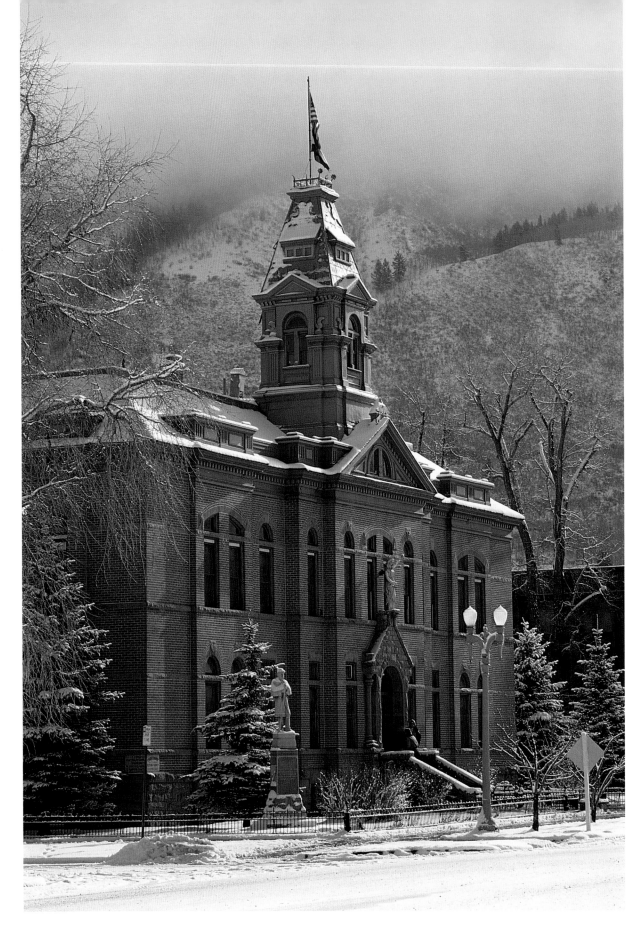

4 *Victorian Architecture*

Architecture dresses a community in the desired style of the day. When Aspen was in the full swing of its prosperity during the late 1880s and early 1890s, the Victorian era was in vogue.

Despite their ungainly, impractical and ostentatious design schemes, the Victorian models from which homes were built during Aspen's heyday show a desire to bring the outside world to the Roaring Fork Valley. Here was the means of infusing culture within a pioneer community at 8,000 feet in the Colorado Rockies. This influx of substantial and extravagant homes helped to validate the struggling mining town as a bona-fide city.

Victorian architecture offered Aspen a rooting in the bedrock of established design and conservative cultural values. By mimicking the cities of the eastern United States and Europe, builders and designers thought Aspen might share the same status and lasting identity. And for the prominent citizens of the day, the Victorian look provided evidence that they too had achieved an enviable level of wealth and stability.

The Victorian era came full force to Aspen with the arrival of the railroads in 1887. The burgeoning industrialization of the U.S. made it possible to weigh down incoming freights with pianos, oak banisters, chandeliers and the trappings of prosperity. The tons of rich silver ore leaving Aspen returned in the form of cherished material belongings.

Homes sprung up adorned with gingerbread filigree, multipeaked roofs, tall, narrow facades with tall, narrow windows, and ornate detail wherever it could be applied. The floor plans were often irregular and the added complexity challenged builders and mocked the bitter winters and deep snows of the Central Rockies.

The dressing of Aspen in Victorian chic was no longer the sole charge of its wealthiest citizens; it became the fascination of any man able to afford mass-produced items. Victorian architecture spread like a well-fanned fire, from West End mansions to East End miners' cottages.

FACING PAGE *Dusted by a light cover of snow, the Pitkin County Courthouse displays Victorian finery and a sense of substance and stability as the seat of law and government in what was a remote outpost at the time of its construction.*

THE GAY NINETIES

ABOVE *A well-preserved Aspen Victorian is bedecked with bright red crab apples.*

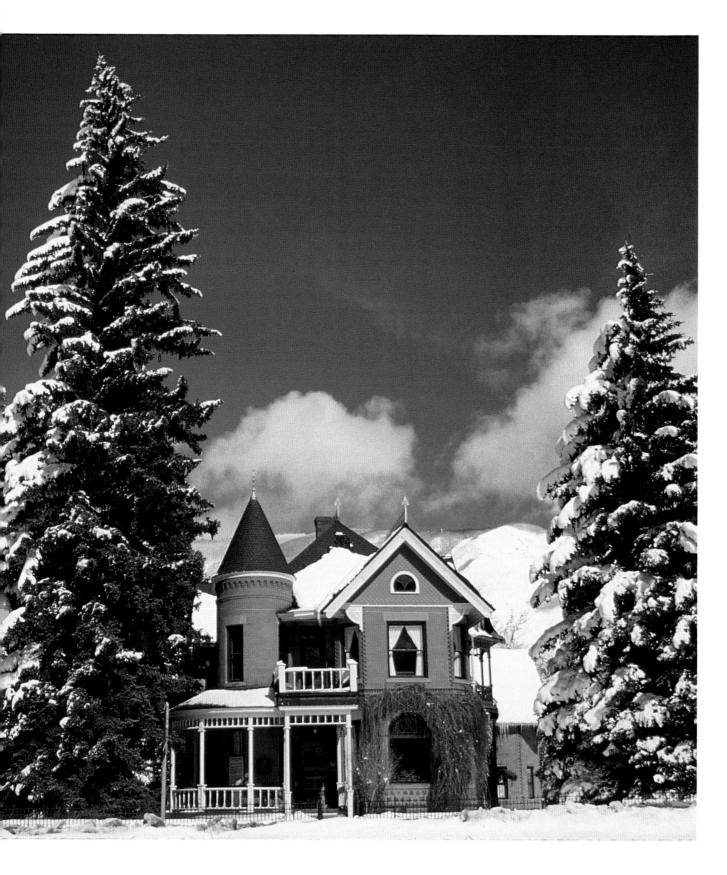

After the silver crash in 1893, however, most of Aspen's homes were boarded up and abandoned. Some Victorians were torn down for firewood, others were moved piecemeal downvalley or sold at giveaway prices. During the decades of Aspen's Great Depression the surviving homes endured the harshness of the weather, slowly decaying with peeling paint and sun-dried wood.

When tourism and skiing gave Aspen its rebirth in the late 1940s, the Victorians appealed to a new group of residents who enthusiastically refurbished them. Aspen visionary Walter Paepcke hired Bauhaus architect Herbert Bayer to lay the aesthetic groundwork for the new Aspen. Paint was offered free to anyone who would put a fresh coat on their home—in a conforming color scheme, of course.

FACING PAGE *The Sardy House, built in 1892, shows its age by the giant spruce trees rising high above its roof. The elegant Aspen home was built to last, with its walls four bricks thick. The Sardy House has been converted into a luxurious hotel and dining room.*

With the gentrification of old Aspen, the once neglected Victorians returned to their previous beauty. Today homes that sold for only a few thousand dollars in the 1940s are on the market for millions. As a National Historic District, designated by Congress in the mid 1970s, Aspen has a responsibility to maintain its architectural integrity. The remaining Victorians are carefully protected by a strict Historic Preservation Committee which scrutinizes every new home, addition or demolition in the Victorian neighborhoods.

ABOVE *Quaint and small, an Aspen miner's cottage is a statement of utility and form. Even the common man in Aspen aspired to Victorian architecture as a sign of prosperity.*

Many of Aspen's Victorians are centerpieces of today's resort community, effortlessly spanning a century of intervening history. The Sardy House, a handsome brick home built on Main Street in 1892, has been renovated and expanded into a plush hotel. The original walls are four bricks thick. The Elisha House (1890), also on Main Street, is a tall, wood-framed home converted recently into office space. The Wheeler-Stallard House, built in 1889 by Jerome B. Wheeler on West Bleeker, is the home of the Aspen Historical Society, which offers tours of its authentically decorated rooms.

Aspen's West End has the highest concentration of Victorians and is a popular place for a stroll beneath the shade of mature cottonwoods. Springing up among the old homes is a generation of Neo-Victorians, which try to match the originals with turrets, iron grillwork and fancy roof lines. By mimicking the old Victorians, these new homes give credence to a beautiful style of architecture.

5 Hotel Jerome

Jesse Jackson reached the podium through a throng of applauding supporters to address the faithful. The ballroom of Aspen's Hotel Jerome was bedecked with bunting and charged with excitement. Jackson's voice rang out as he ticked off the points of his platform. The year was 1988 and Jackson was seeking the Democratic Party's nomination for President of the United States.

The Hotel Jerome is no stranger to dignitaries. Its guests have included celebrities like John Wayne, Gary Cooper, Lana Turner, Hedy Lamarr and Thornton Wilder. Renowned as one of the best hotels in the West, the Jerome was meant to match Aspen's ascendancy as one of the richest silver mining cities in the world.

The original 90-room hotel was built in 1889 by Jerome B. Wheeler, whose name is closely linked with the town's colorful history. Wheeler, one of the town's greatest benefactors, came West in 1883 from New York City, where he was president of the prestigious Macy's Department Store.

Wheeler was one of the great believers in Aspen and he plowed Eastern capital into numerous enterprises, including a smelter, a bank and a number of mines. Chief among his investments was a bonanza called the Molly Gibson, considered the richest silver mine in the world. The Hotel Jerome was to rival accommodations in Denver and New York in its stature and elegance, bringing Aspen an exalted prominence Wheeler thought it deserved.

The site for the new Hotel Jerome was selected for the corner of Main and Mill Streets in Aspen, and ground was broken in 1888, only one

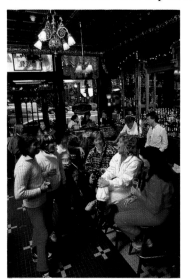

year after the railroads had arrived. Beginning an Aspen tradition, the hotel ran far in excess of budget and was finished at the grand cost of $160,000. Rather than rue the fact, Wheeler threw a grand opening celebration, inviting guests from as far as New York and Paris. The revelers danced until 2 a.m. in the grand ballroom of "the pride of Aspen."

Known for its lavish style and amenities, the Hotel Jerome boasted a marvelous innovation called an elevator, one of Colorado's first. Steam heat and hot and cold running water provided hotel patrons with all the comforts.

LEFT *The renovated bar at the Hotel Jerome remains a popular watering hole for Aspen's diverse social mix.*

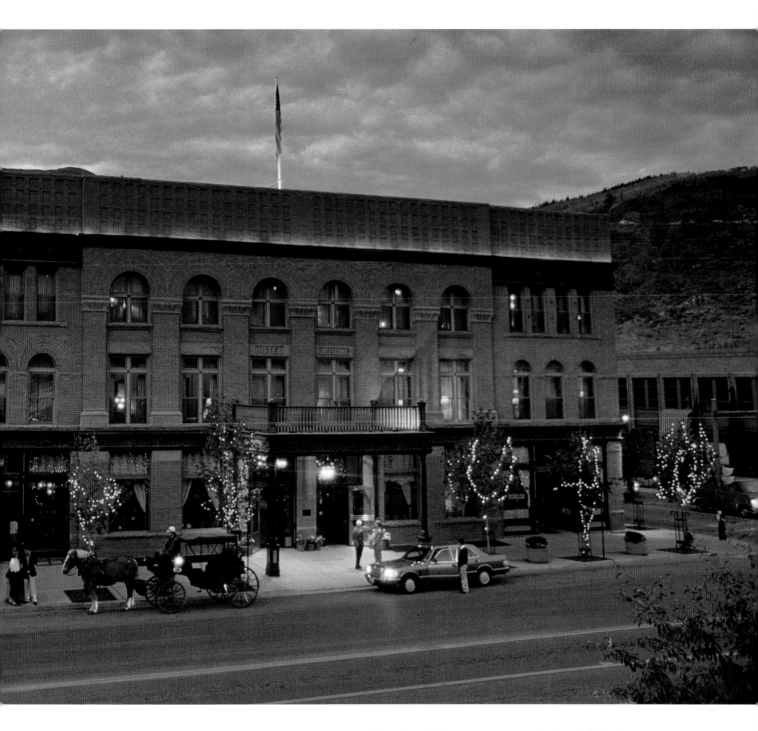

ABOVE *A hotel to rival New York and San Francisco, the Jerome was Aspen's best. Equipped with an elevator, steam heat, hot and cold running water and a paging system, the hotel defined Aspen's ostentation and hubris. The Jerome, refurbished several times, remains a true Aspen gem.*

Frescoes, leather-upholstered chairs and a grand piano completed the plush decor. Uniformed bellboys, a garden greenhouse, a paging system and horse stables rounded out the hotel's services.

The Jerome floundered through the silver crash of 1893, when Aspen fell into a severe economic depression. However, the hotel remained a prominent Aspen landmark that has adapted to the times. During World War II the hotel was home to soldiers of the Tenth Mountain Division, an elite ski troop that trained near Aspen and included in its ranks many of today's most influential Aspen citizens.

The hotel was swept into a new era when it was leased in 1946 to Walter Paepcke. His wife, Elizabeth, had first stayed there during a 1939 ski trip for three dollars a night when the food, she reported, was "awful." Paepcke, who played the foremost role in Aspen's rebirth as a resort, renovated the building and installed a swimming pool. It became a hangout for the new cognoscenti of Aspen in 1947, when the Aspen Mountain ski lift opened and the Aspen Idea was hatched.

During the 1960s the Jerome was the pulse of the town, a popular watering hole where a drink called the "Aspen Crud" (a milk shake laced with bourbon) gained popularity among skiers. But without adequate upkeep the hotel deteriorated. Instead of first class, by the late 1970s it was reduced to near flophouse status.

In 1987 the Jerome was again rescued, this time by a well-financed group of investors led by Dick Butera, which bought the hotel and put $6 million into the landmark. A wing of 67 rooms was added, as was underground parking, a tea room, the Antlers Bar and a new ballroom. The pool was replaced by a garden with a smaller pool, and the building was painstakingly restored to its former elegance, including authentic furnishings from the 1890s.

Most Aspenites have fond memories of the Hotel Jerome. Whether for lavish fund-raising balls, raucous halloween bashes, jazz festivals or après ski parties, the Jerome has been a focal point for Aspen that has transcended the decades with a grace and style all its own.

LEFT *The outdoor setting and the mining history of Aspen is reflected in details in the Hotel Jerome such as these antlers from a hunter's trophy of the past.*

UPPER RIGHT *Restored to its authentic grandeur, right down to the fixtures, the Jerome elicits a stirring sense of history and serves as a meeting place for a diverse community.*

LOWER RIGHT *The flavor of the Wild West is still part of Aspen's ambiance as a cowboy and his horse look for something to wet their whistles at the Jerome.*

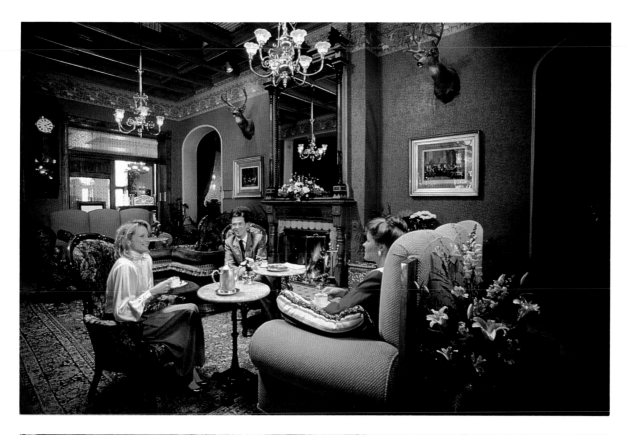

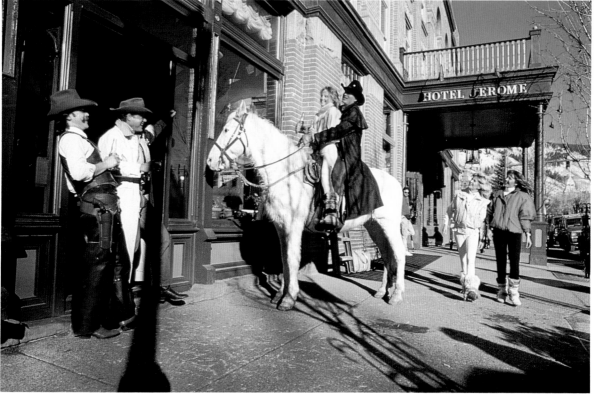

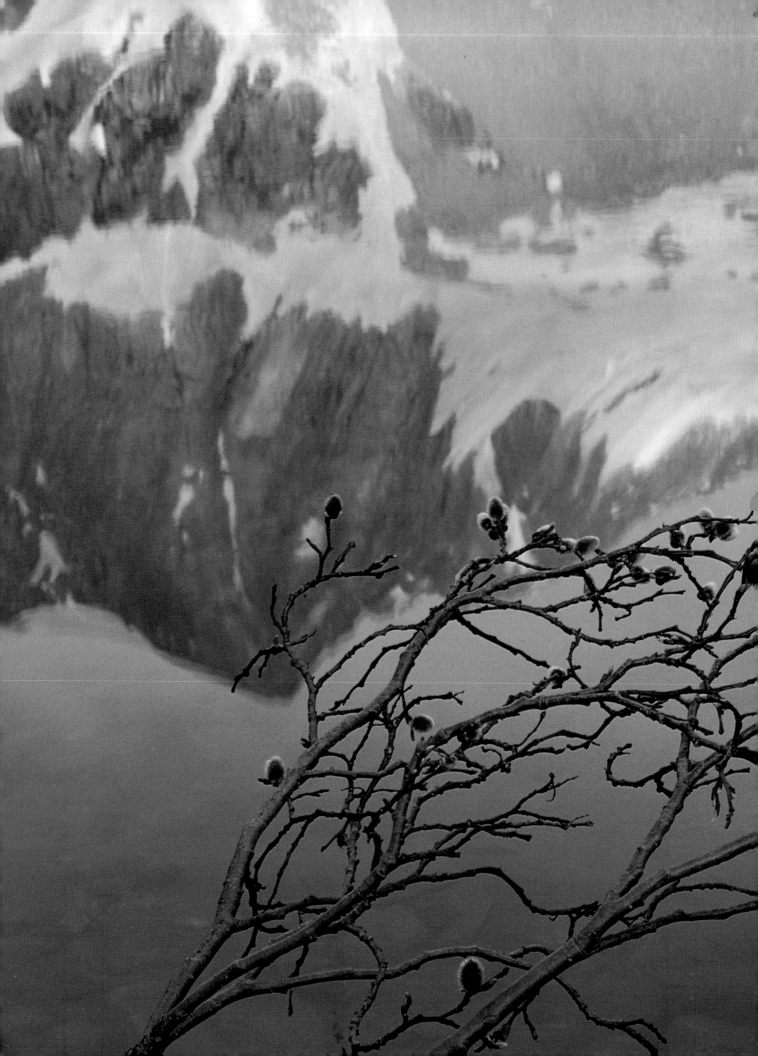

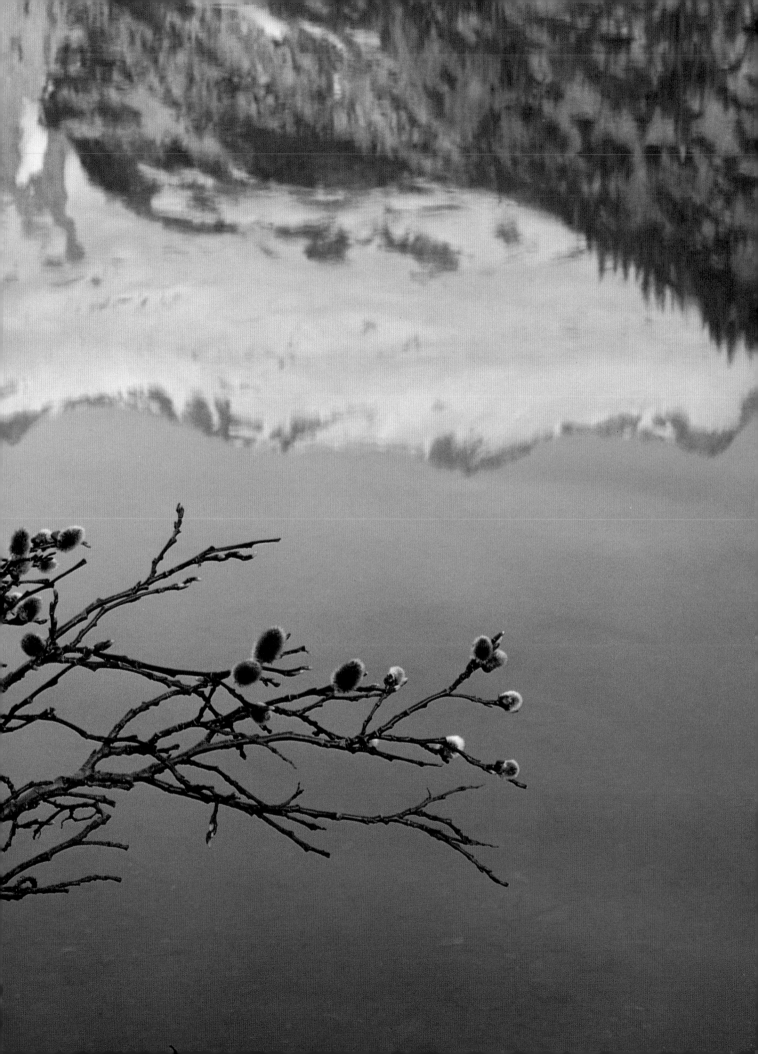

6 *Wilderness*

Wilderness is a concept that implies man's absence. It is an idea that rests in the back of the mind, where it furnishes a source of security, consistency and sanity. Wilderness in a rapidly changing world remains one of the last great constants, a place where man can mark his life against the perfection of nature and discover a sense of awe in living.

Beyond the esoteric, wilderness also bears a definition handed down by the U.S. Congress, which created the Wilderness Act of 1964 as a means of protecting pristine lands. Wilderness, said Congress, is a place where the forces of nature supersede the imprint of man, where the land is undeveloped and should retain its primeval character without permanent improvements, where humans are visitors, not inhabitants, and where solitude and primitive, unconfined recreational opportunities exist.

In Aspen, wilderness is best characterized by the Maroon Bells-Snowmass Wilderness, 174,000 acres of alpine majesty forming a substantial backyard for a community of mountain climbers and hikers, backpackers and equestrians. It is one of the best-loved nature sanctuaries in the lower 48 states, visited by tens of thousands of people each year.

There are currently 25 wilderness areas in Colorado, with a combined area of 2,586,807 acres. With the Hunter Fryingpan Wilderness bordering Aspen to the east and the Collegiate Peaks and Maroon Bells-Snowmass wilderness areas to the south and west, the fundamental values of nature are within easy reach. Three other wilderness areas—the Raggeds, Holy Cross and Mt. Massive—are close enough to make Aspen a pivot point for access to pristine alpine basins, rushing trout streams and placid, high-altitude lakes.

Entering a wilderness carries strong implications. Past the trailhead, where wilderness users are requested to sign in, the narrow, dirt trail threading among conifers, aspen and wildflowers, takes on a new meaning. No motor vehicles or equipment are allowed, transportation must be nonmechanized—which even means no mountain bikes—and no cabins or structures may be built.

PRECEDING PAGE *Willow buds reflected in Snowmass Lake frame a view of Snowmass Mountain on a spring day when runoff from snowmelt refreshes mountain streams and lakes.*

FACING PAGE *Near tree line in the Maroon Bells-Snowmass Wilderness, a fallen spruce begins the cycle of decay and rebirth.*

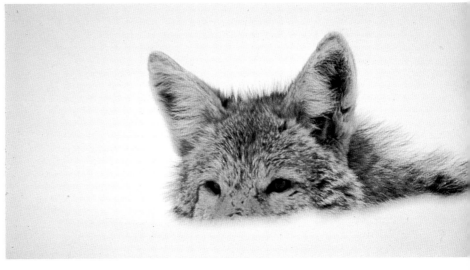

ABOVE *A coyote, the most pervasive predator in the Rocky Mountain West, crouches stealthily in the snow, its ears and eyes always on the alert.*

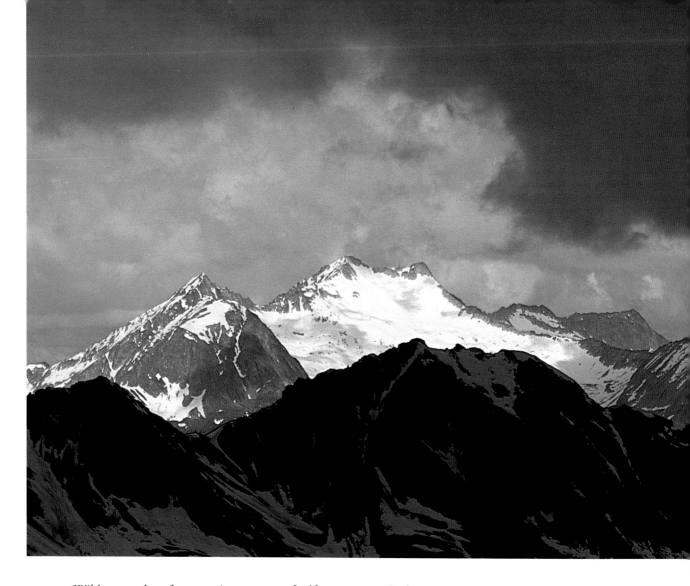

Wilderness, therefore, requires a sense of self-assurance, which is perhaps the greatest lesson it teaches. Personal risks are impressed more strongly on the subconscious, and the senses are heightened to a peak. Wildlife and wildflowers abound, and nature is more pronounced. There are fewer trail markings, only rough log bridges, and maps become critical for negotiating the rugged landscape.

With self-assurance comes freedom and with freedom comes a personal sense of responsibility for maintaining the domain of nature. Dogs must be kept on a leash, groups of people are limited in number, open fires are forbidden in many areas, and no-trace camping is a standard requirement. In short, nature must remain predominant.

Wilderness, which makes up roughly two percent of the land mass of the lower 48 states, carries a philosophy that is supported by its advocates with an almost religious fervor. As an ultimate expression of the sacred rights of nature, wilderness affords man the rare opportunity to commune with a primitive side of life far from the distractions of the mechanized, electronic world. Nature is protected so that man may enjoy a shift in perspective and better understand his place in the universe.

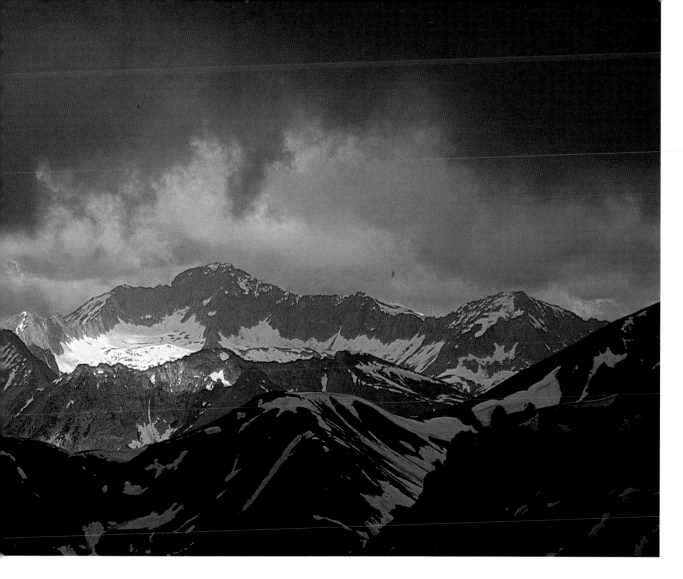

The politics of wilderness is heated and emotional. Some argue that wilderness is elitist and available only to the young and the fit. But as more and more wilderness users discover a transformational experience in serenity and natural beauty, a growing coalition is working for wilderness preservation and new designations by Congress. Wilderness water rights are at the core of most debates on new designations within the Rockies, with downstream water users hoping to develop water resources within the wilderness, even at risk of reducing stream flows and depleting aquifers.

The issue is balance, say conservationists. Wilderness serves as a repository for species diversity, a catalogue of plants and animals that has a growing significance to man's future. Wilderness is a control group in the experiment of human development, resource extraction and industrialization.

After a hike up Snowmass Creek to the glistening snowfields on the shore of Snowmass Lake, or a stroll along Conundrum Creek where deer inhabit the woods and meadows and birds chatter in the willows, the world of man is diminished. Nature exerts herself and gives reason for man's humility and respect. For that, wilderness has inestimable value.

ABOVE *A picket fence of mountain peaks includes two of Colorado's "fourteeners," Capitol Peak and Snowmass Mountain, amid the drama of a stormy sky in the heart of the Maroon Bells-Snowmass Wilderness. This pristine landscape is a haven for hikers and equestrians who seek a primitive experience in the Colorado high country.*

7 Wildflowers

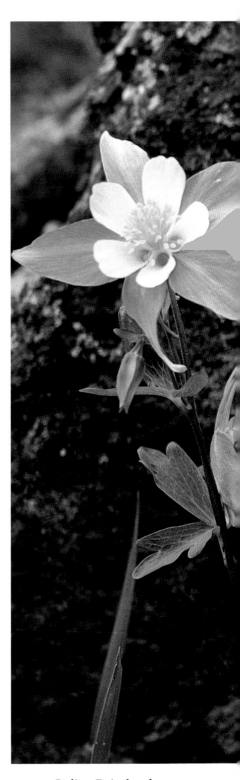

The Pasqueflower is one of the first exotic blooms to push skyward in the springtime, ushering in a welcome change to the seasons with its subtle, violet beauty. Both elusive and rare, the Pasqueflower may be found in the wet valley floors amid dense woodlands. As the False Hellebore, or Skunk Cabbage, thrusts upward in bold, exuberant shoots only inches from the retreating snowpack, wildflowers add a colorful bonus to the late spring when the weather is fickle and the rivers are high.

Beginning in May at lower elevations, the wildflower spectacle moves slowly into the high country as snow retreats and runoff saturates the ground. Mountain Lady's Slipper, Monkshood, Lupine, Aster, Elephanthead, Fireweed, King's Crown, all follow the snow line as if on a pilgrimage. Colors range from the bright pink of Fireweed to the royal blue of Blue Harebell. Cinquefoil blooms in the valleys, yellow Arnica brightens a spruce forest glade, and Evening Primrose opens its broad, white petals on a rocky slope green with scrub oak.

When the high country reaches its midsummer peak, flowers of every description pattern meadow and tundra with a bold splash that attracts the buzz of insects and the dive-bombing of hummingbirds. Wildflower meadows exert a hypnotic allure, and within this variegated mural—always changing and fluid— there is a story behind each individual in the community.

According to Roger Tory Peterson's *Field Guide to Rocky Mountain Flowers*, a Bible for amateur botanists, every bloom and stem has a property, and not all of them are benign. The Pasqueflower contains a medicinal oil, but can also be fatal to sheep that overgraze it. The Primrose produces edible seeds and roots used traditionally for food by American Indians. Fireweed is a favorite forage of the grizzly bear and one of the first plants to sprout after a forest fire. The

LEFT **Indian Paintbrush make a flowery bed for a resting hiker.**

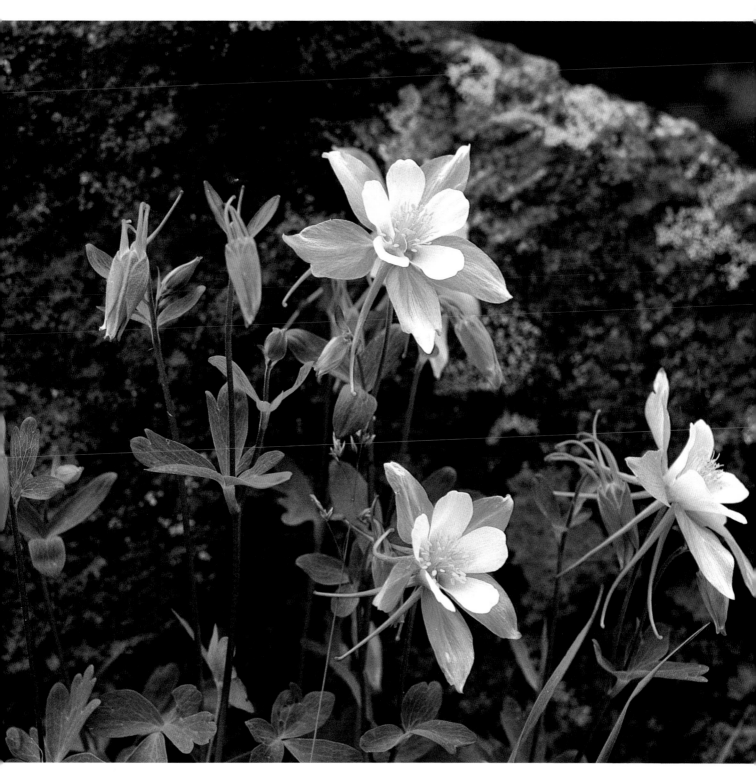

ABOVE *Blue Columbines, fragile and delicate, are the Colorado State Flower and* *grow in stunning bouquets among boulder fields, meadows and forests. These popular* *blooms are protected by law and carry a fine if they are picked.*

oil from Arnica kills infection and is a highly valued medicinal plant. Monkshood is the source of the drug aconite, used as a heart and nerve sedative.

Wildflowers are nature's artwork as well as her apothecary, and their importance to science is well known. It was the Primrose that Hugo de Vries, a Dutch botanist, grew in his garden around the turn of the last century. From his observations of the Primrose, de Vries formulated the theory of evolution by mutation.

As a highly valued aspect of the natural landscape, wildflowers are paid special attention. In Colorado's Recreation Land Preservation Act of 1971, it is made a crime to "willfully cut down, break or otherwise destroy any living tree, shrubbery, wildflowers or natural flora." The maximum fine is $500.

The Colorado Blue Columbine, discovered by botanist Edwin James in 1820 and protected by law in 1825, was decreed the state flower in 1899. It derives its name from the Latin word *colomba*, which means dove. Its long spurs and petals were thought to resemble a circle of doves dancing around the stem. Native Americans used a tea made from the Columbine's seeds to cure headaches and fevers.

Indian Paintbrush is one the most easily recognized mountain wildflowers and covers meadows in July. It blooms in bright red, pink, orange and yellowish-white and is named from its paintbrush-like flower.

Picking a bouquet of wildflowers is a strong temptation, but it interrupts reproduction and deprives others of the opportunity of seeing for themselves nature's palette in the wilds. Whether as the delicate Alpine Forget-Me-Nots crouched low in the tundra, or the towering Green Gentian, or Miner's Candle, bursting with blossoms in a forest glade, wildflowers describe the beauty of nature's handiwork with symmetry and brilliance.

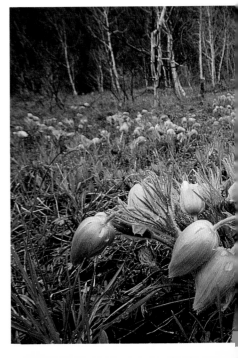

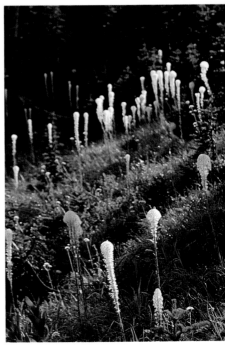

UPPER LEFT *A delicate early bloomer, the Pasqueflower arrives before leaves have sprouted on aspen trees.*

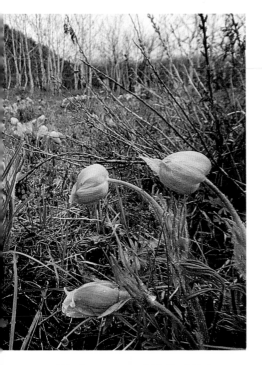

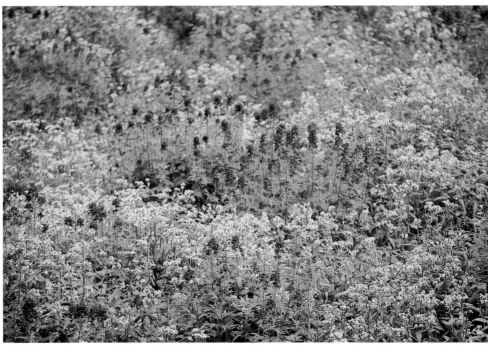

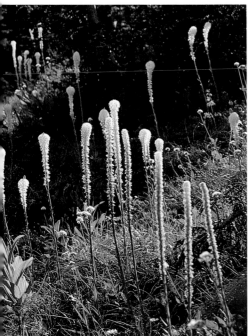

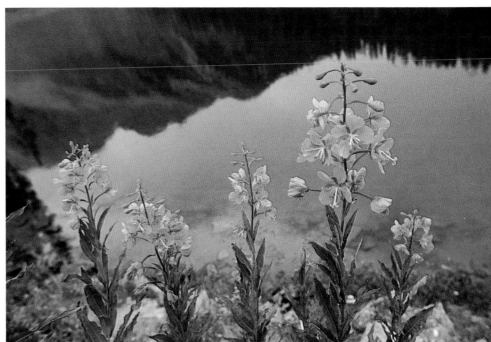

Beargrass stands tall in an alpine meadow, its plume illuminated by bright mountain sunshine.

A wildflower meadow is a blend of colors from nature's own palette.

Fireweed is one of the first plants to revegetate after a forest fire and is a favorite forage of the grizzly bear.

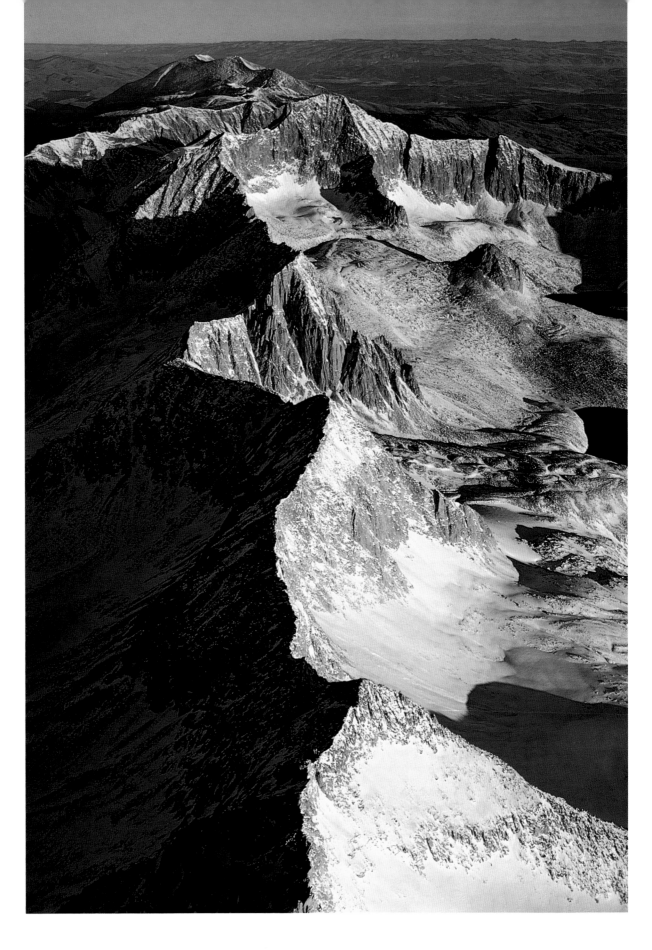

8 Prominent Peaks

The Maroon Bells are among the most photographed mountain peaks in the world. Named by explorer Frederick Hayden in the 1870s for their bell shape and reddish hue from the weathering of hematite, an iron-bearing mineral, Aspen's most prominent peaks are a magnet to millions of visitors who pay them homage with the click of a shutter.

Rising above Maroon Lake in jagged twin towers, striated with snow and ice, the Maroon Bells reduce human importance and mock human scale. Maroon Peak (14,156 ft.), South Maroon Peak (14,014 ft.) and dozens of other prominent mountains in the Aspen area have the power in their lofty stature to humble man.

These mountains are frequently climbed and even skied by a daring few. But such summit triumphs come at considerable risk and cost. Fatalities almost every year are reminders that gravity holds the ultimate trump card. The "Deadly Bells," a rather morose nickname, are so-called because of the rotten rock from which they are made.

An Austrian rock climber with first ascents of major mountains to his credit explains his drive for climbing with the word "dimension."

FACING PAGE
Capitol Peak and Pierre Lakes Basin are part of the rugged Maroon Bells-Snowmass Wilderness Area in the White River National Forest, an ideal spot for alpinists who like exposure and backpackers unafraid of aerobic activity.

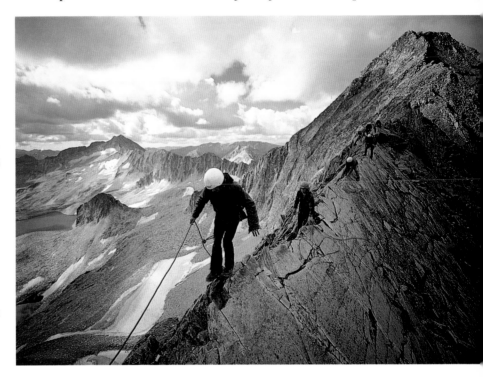

ABOVE *Climbers walk a tightrope on the knife edge of Capitol Peak, 14,130 feet, one of the dominant and striking summits in the Maroon Bells-Snowmass Wilderness.*

Measuring a tiny gap between thumb and forefinger, he indicates human scale. Opening his arms wide and embracing space, he defines the world of the alpinist. It is this sense of dimension, he says, that creates for him a lasting appreciation of mountain peaks.

The average height of peaks in the Rocky Mountains is 8,000 to 12,000 feet. In Colorado, there are more than 500 peaks over 12,000 feet and 54 peaks over 14,000 feet. The "fourteeners" are sought out by climbers from around the world who revel in the dimension achieved from a summit view. Peaks rise up in all directions in a staggering display of geologic time and tumult.

The pinnacles and ridge lines of prominent peaks are handy

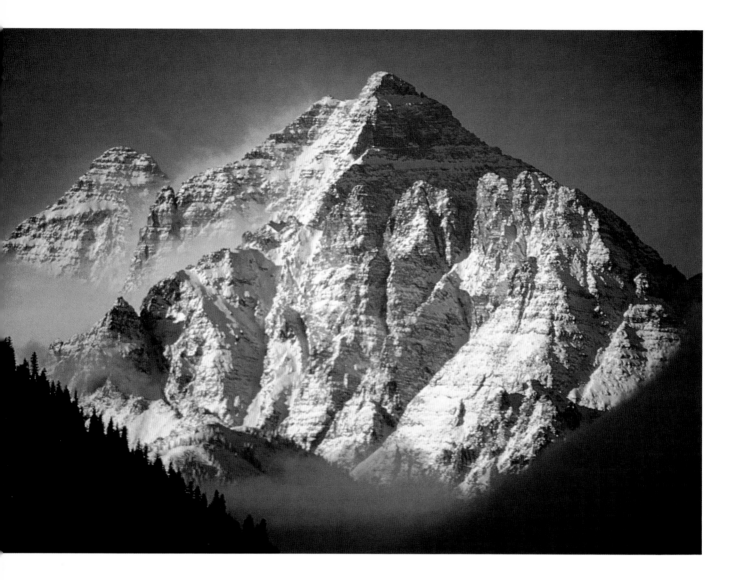

geographical points of reference that allow for quick orientation in a vast landscape. In the Snowmass area, Snowmass Mountain (14,077 ft.) can be easily identified from many angles by its huge, open snowfield, a white immensity against the predominant mass of dark, gray rock. Capitol Peak (14,130 ft.) rises above the other peaks with its pointed summit and knife-edge ridge. Mt. Daly (13,380 ft.) is recognized by a huge stripe across its east face, as if painted there.

From Independence Pass, at over 12,000 feet, the prominent mountains of the Elk Mountain Range between Aspen and Crested Butte stand out clearly against the western horizon. To the east near Leadville in the Sawatch Range are some of the highest peaks in Colorado—Mt. Massive (14,421 ft.) and Mt. Elbert (14,433 ft.), the tallest in the state.

From practically any point in the lower Roaring Fork Valley, Mt. Sopris (12,953 ft.) creates a pivot point with its powerful mass and isolation

ABOVE *Pyramid Peak, 14,018 feet, stands sentinel-like in the Maroon Creek Valley, a massive outcrop of vertical rock. Pyramid is a favorite summer climb and has been skied several times by local mountaineers.*

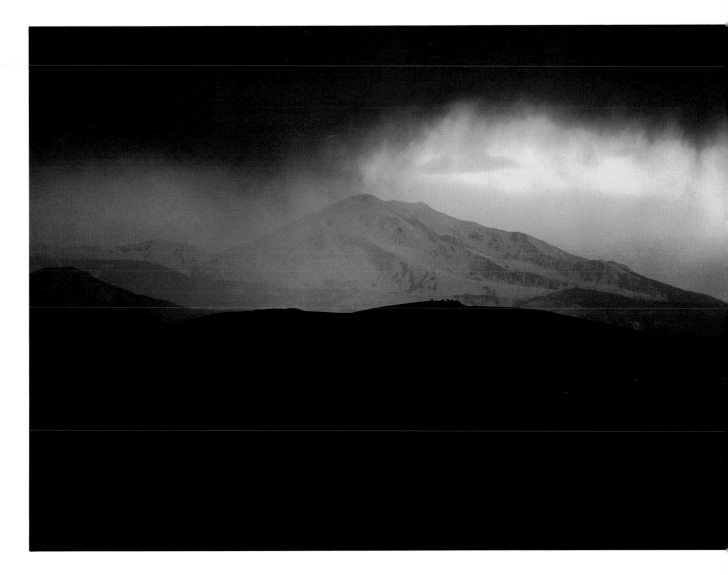

in the valley floor. It is no wonder the Ute Indians attached spiritual significance to Mt. Sopris. It stands majestic and alone and is easily recognized from any direction.

A glance at Pyramid Peak (14,018 ft.) from Highway 82 near Aspen or from the Maroon Creek Road brings the alpine experience clearly into focus. Whether draped in swirling clouds, mantled with snow or standing in silhouette against a setting sun, Pyramid shows the dramatically changing face of nature in a stark, vertical world.

Booming thunderstorms, raging rivers, thundering avalanches, the biting wind, all have challenged man in his outdoor quests. But the mountains seem unassailable. They are mute, stoic survivors of tens of thousands of years of withstanding such forces. Their very endurance demands awe and respect.

ABOVE *Mt. Sopris, 12,953 feet, dominates the lower Roaring Fork Valley. Easily identified from many points in the valley, Mt. Sopris was holy for the Ute Indians.*

OVERLEAF *Pyramid Peak and the Maroon Bells cordon off the Maroon Creek Valley, creating one of the most rugged, scenic vistas within the Elk Mountain Range.*

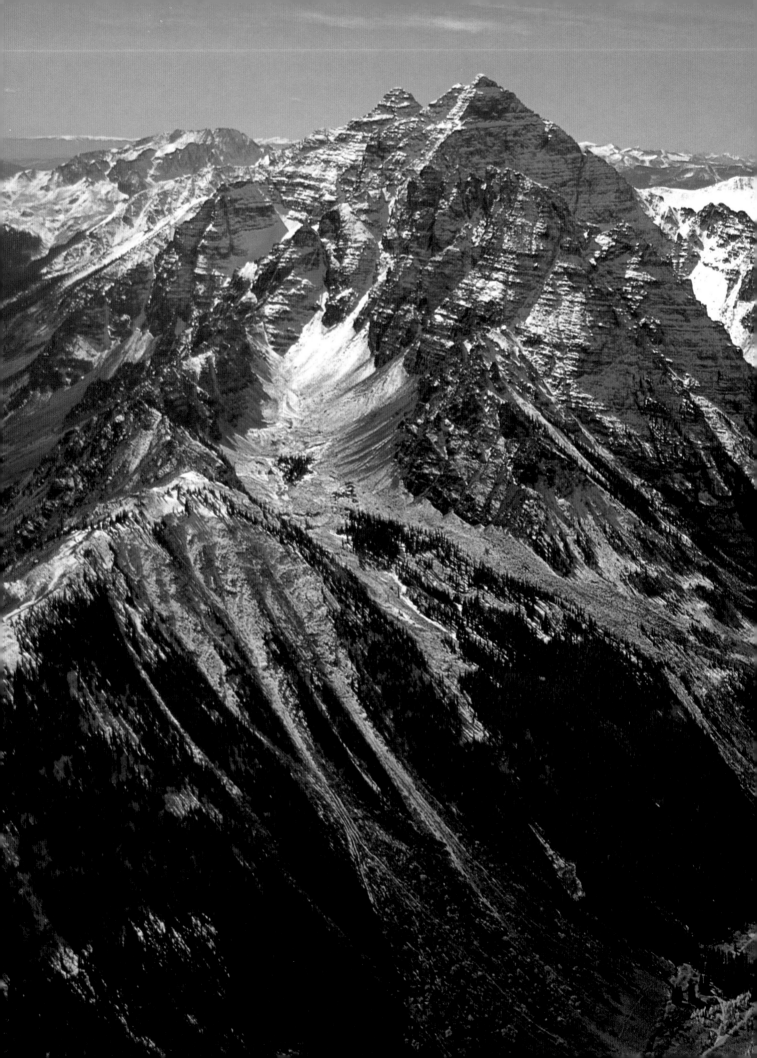

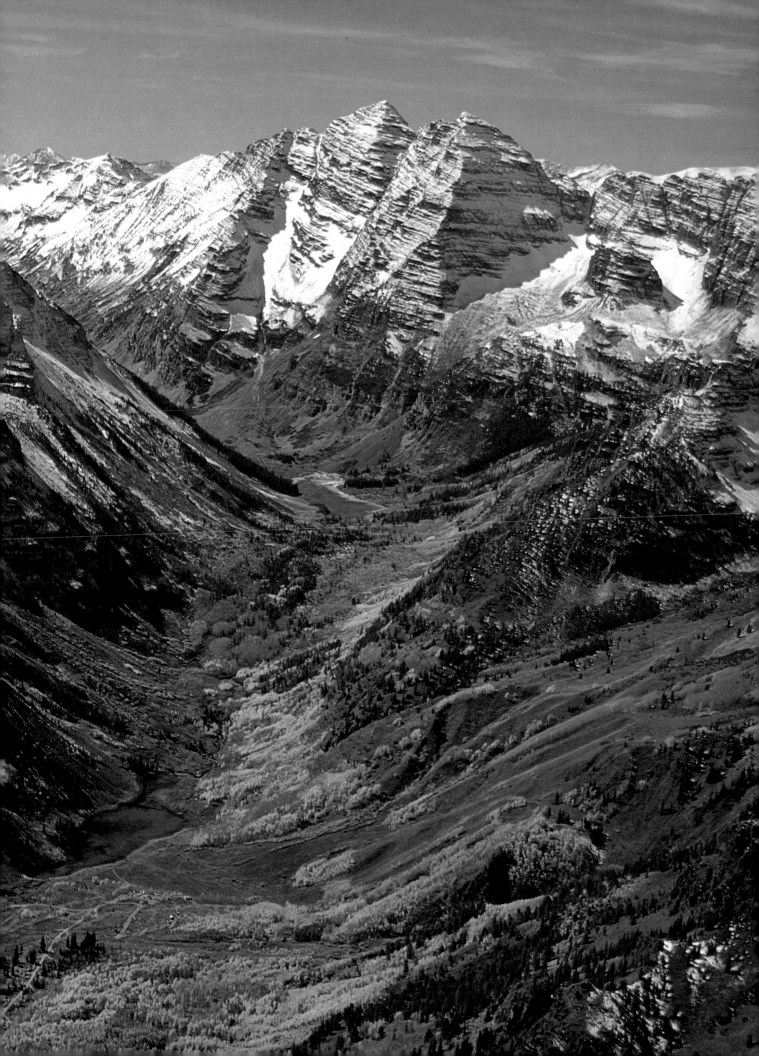

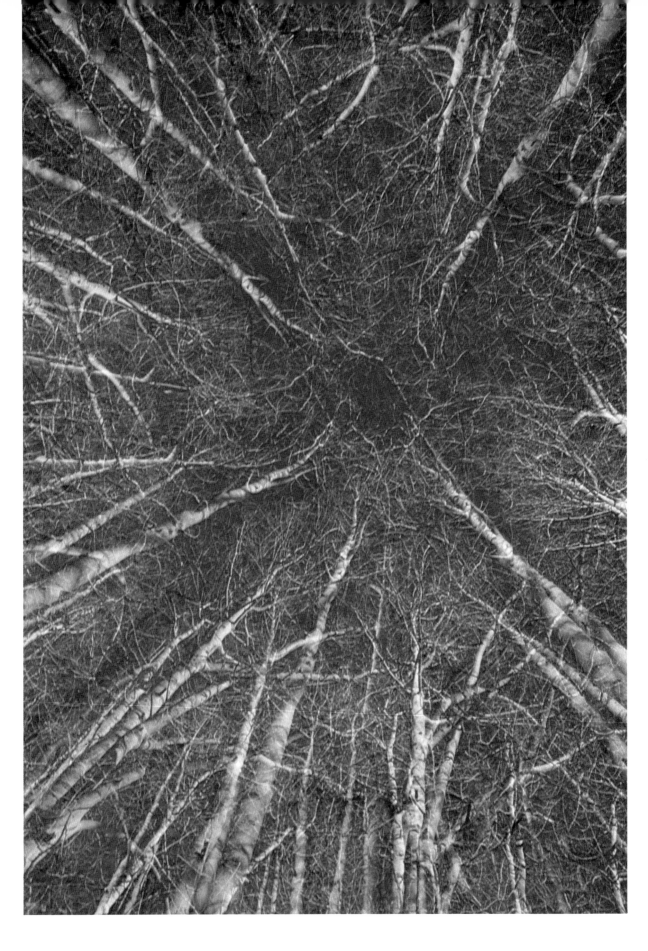

9 Aspen Trees

No tree is as quickly identified with the Rocky Mountains of Colorado as the aspen. It is the most widely distributed tree in North America, ranging from Alaska to Newfoundland and as far south as Arizona and Virginia. It serves as predecessor to the conifer in the natural evolution of forests, and is browsed by deer, elk, moose, sheep and goats.

The aspen tree was so plentiful in the upper Roaring Fork Valley in the 1880s that the bustling mining camp first known as Ute City was renamed Aspen in homage to this ubiquitous member of the poplar family. The *populus tremuloides*, or quaking aspen, is so-called by the nature of its leaves, which flutter in the slightest breeze. The tree propagates through its root system, which sends out shoots, so that contiguous forests are linked by a common subterranean bond.

FACING PAGE *Their trunks straight and tall, aspen trees reach toward a blue Colorado sky, their branches creating a filigree of intricate patterns.*

In a forest of Aspen trees on a mountain flank near Aspen where a popular hiking trail follows the contours of a steep ridge, the aspen trees stand tall and straight, with only an occasional evergreen growing erratically among them.

Hiking through this grove, the trees show the signs of man and animal with scars on their soft, white bark. Where man has carved with a knife, the names, dates and initials stand out in black, crusty curlicues. Some date from the 1930s and bear the names of Basque shepherds.

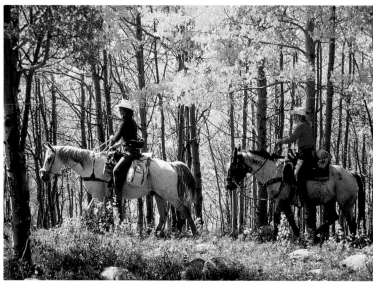

ABOVE *Horseback riders walk their mounts among aspen in full autumn plumage.*

Other aspen carry the sharp-edged doodling of hikers with romantic notions whose intent may not be malicious but is nonetheless damaging. Tree scars offer a vulnerable inroad to insects, and the trees often rot where they stand, precariously balanced by half a trunk and doomed to fall inevitably in a sudden gust of wind.

Other marks on the trees in the aspen grove are not manmade at all but are the work of nature. They show where bears scampered up the trunks, their claws anchoring into the soft, smooth bark in a repeating pattern of five distinct holes. The bear's descent is shown by five deep scratch marks, long and curving, becoming dark and rough as the tree has attempted to heal its wounds.

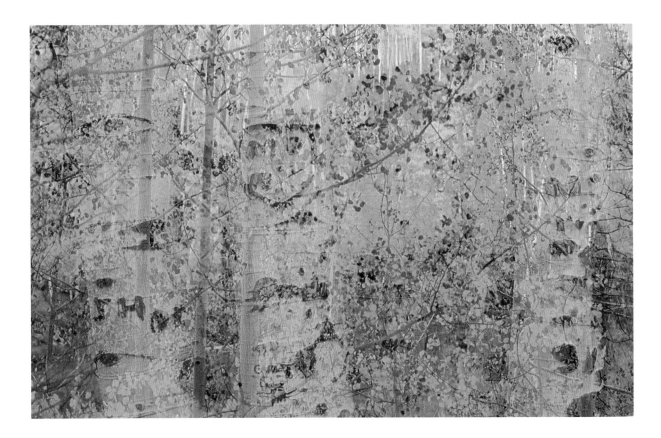

Beavers appreciate the soft wood as dam-building material and the inner bark as a food source. They take down aspen trees, both young and old, big and small, carving out with their sharp teeth the large wood chips that lay in a pile beside gnawed stumps on stream banks and lake shores.

Summer aspen are graceful and lush, sheltering the more delicate plants of the forest floor like rose hips, columbines and ferns, from the rigors of the sun. Walking through an aspen grove is like wandering through a garden, light green in the spring when the leaves are fresh, and a deeper shade of green by July. The sun comes through in mottled irregularity and the leaves rustle with a hushed murmur in the breeze.

Winter aspen stand barren and leafless, striping the uniform snow with their slanted shadows and holding, only momentarily on their narrow limbs, downy clumps of dazzling fresh snow. Where aspen grow on steep slopes they face the constant pressure of a creeping snowpack and show their resilience with permanent twists and bends.

But the glory of the aspen tree is in the autumn, when the leaves turn yellow, orange and red. With a retreating sun low in the blue sky of a fall day, the colorful aspen catch the light and temper it like a filter. And when a breeze catches the trees, plucking leaves and flinging them into the air, they rain down like golden confetti, turning and whirling as they float magically down, covering the forest floor with a yellow carpet.

ABOVE *Aspen trees in abstract show a world of color and texture.*

UPPER RIGHT *The golden hues of aspen are caught in a fall snow that covers evergreens but reveals the aspen in a gilt-edged landscape.*

LOWER RIGHT *In the depths of winter the trunks of aspen yield striped shadows against a uniform, white blanket.*

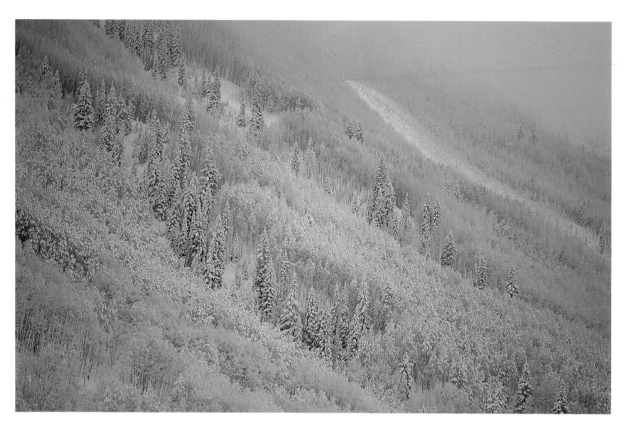

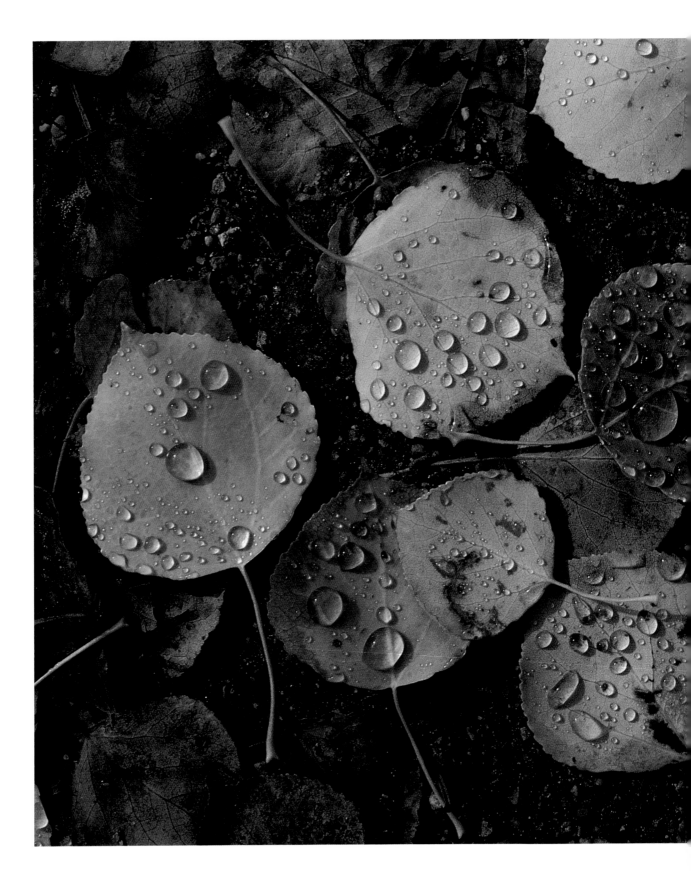

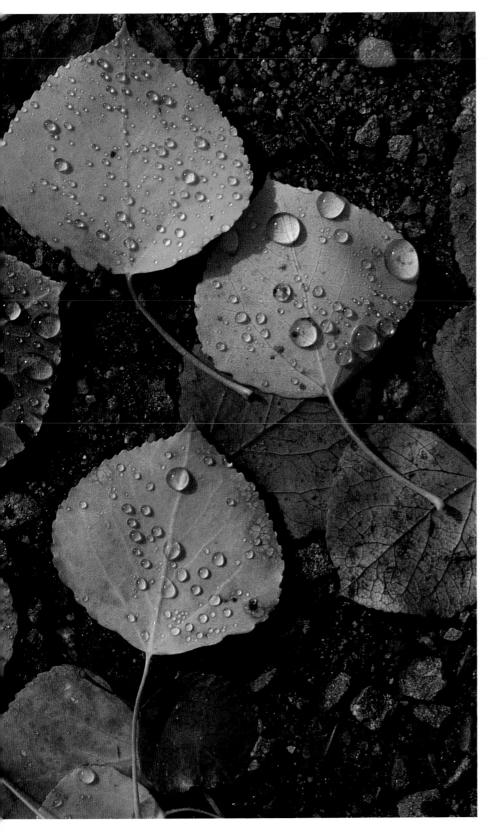

LEFT *Holding tiny droplets of rain, fallen aspen leaves cover the forest floor like a golden carpet, their symmetry reflecting nature's attempt at perfection.*

OVERLEAF *When the fall colors reach a peak, the mountains of Aspen glow with the vibrant hues of the trees that gave the city its name. The flank of Red Mountain (right) and Aspen Mountain (center) hold the sun on a fall morning.*

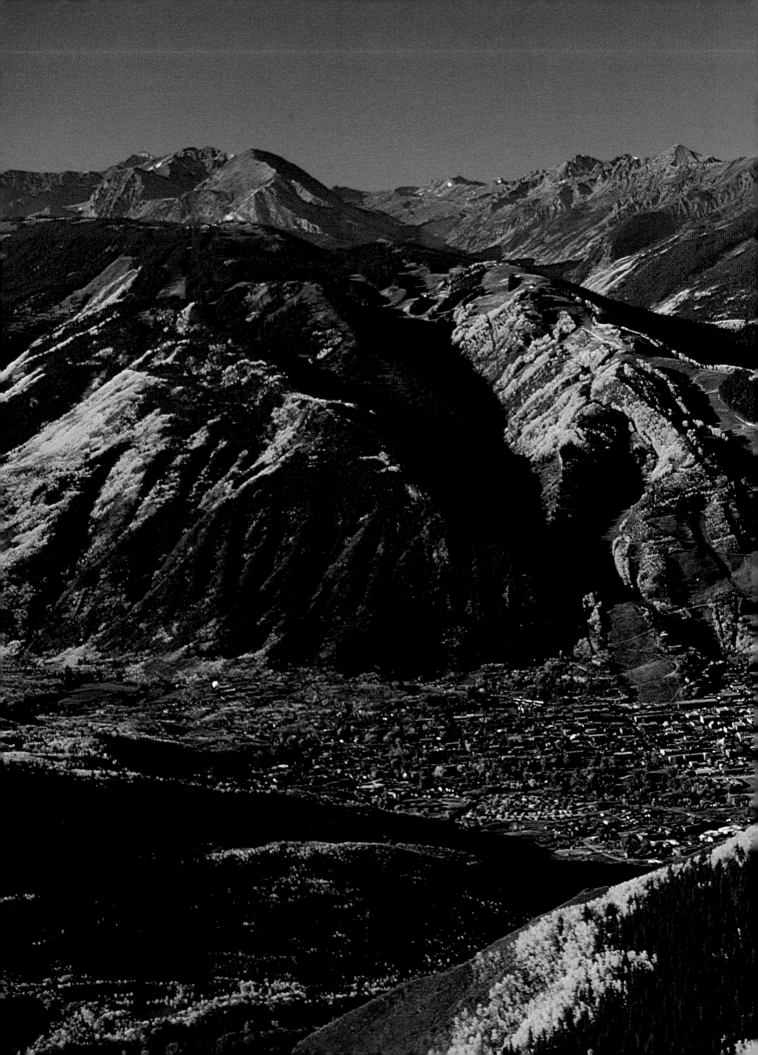

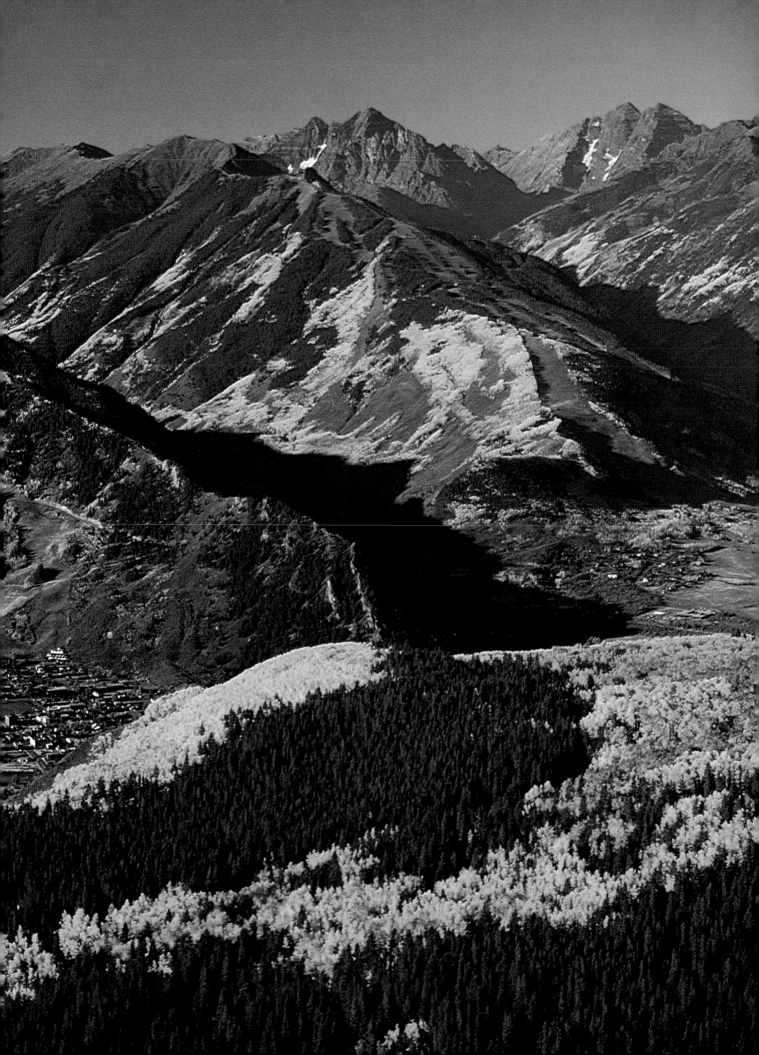

10 Wildlife

Biodiversity is a buzzword within the scientific community. It defines a philosophy of nature that trumpets the importance of all its separate parts. From the yellow warbler to the grizzly bear, "all God's creatures have a place in the choir." Colorado wildlife has sacrificed biodiversity to man's activities over the past century. The grizzly bear and timber wolf are gone and most of the surviving big game is now inventoried and managed by the Colorado Division of Wildlife. Still, the wildlife of the Rocky Mountains is a profound aspect of any outdoors experience.

Hiking into the high country, two of the most familiar animals, the marmot and pika, are constant companions. The marmot is a relative of the woodchuck and shares boulder fields with the tiny pika, a squirrel-like creature that thrives in high altitudes. The marmot, nicknamed "whistle pig," emits a shrill whistle as a warning. The pika perches on hind legs and sends out a startling chirp before ducking between the boulders that furnish shelter and protection for both animals.

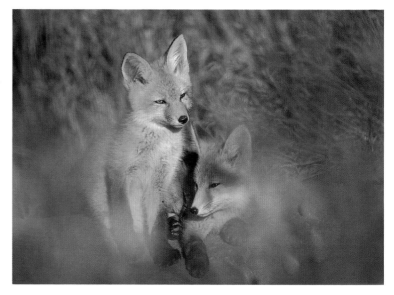

Any camper knows the Gray Jay, or "Canada Jay," for the bold and pesky thieves they are. An unattended camp is fair game for these winged marauders, who will ferret out food that is not tightly locked away and secured. The jays, tame and unafraid of man, are called "camp robbers" for good reason and offer amusement with their antics.

Elk and deer are prevalent throughout the Colorado Rockies, though it requires either luck or good stalking skills to get close. The elk inhabit the high mountains during the summer and gather on timberline ridges, where they bed down on the soft tundra. Deer seek shelter in the dark timber, where their quiet movements cannot be seen. Elk and deer venture out in late evening or early morning for a drink from a nearby creek or lake, or to browse in open meadows. They gnaw the bark of aspen trees when winter snows cover their normal forage.

Bears, mountain lions and bobcats are more elusive still, but are occasionally sighted in the Aspen area. In the spring, bears ravenous from a long winter of hibernation sometimes roam through residential

ABOVE *Fox kits gaze about in a brave new world and abound in the Aspen area where they are frequently seen close to town.*

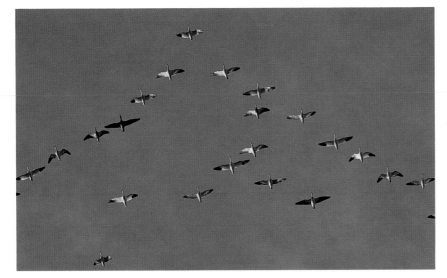

LEFT *Geese fly in an echelon, announcing the changing of the season.*

LEFT BELOW *Caught on a fly and expertly netted, this rainbow trout was promptly released for other anglers to try their skill in area streams and rivers.*

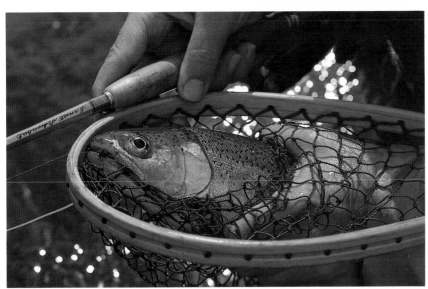

neighborhoods in search of a full trash can. Mountain lions show themselves only occasionally, but have a substantial population in Colorado. Bobcats are rarely seen.

Bighorn sheep, with their tawny, gray coats and thick, curled horns, are found in herds above timberline, where their agility and sharp eyesight protect them from predators. They share the lofty summits with mountain goats, whose white coats and small, black horns make them easy to recognize while they scramble along vertical ridges with seeming impunity. These are the true kings of the mountains.

Coyotes are the most visible and audible predator in Colorado. Their collective voices ring out day and night and sound like teen-agers whooping it up at a party. Despite being subjected to traps, organized

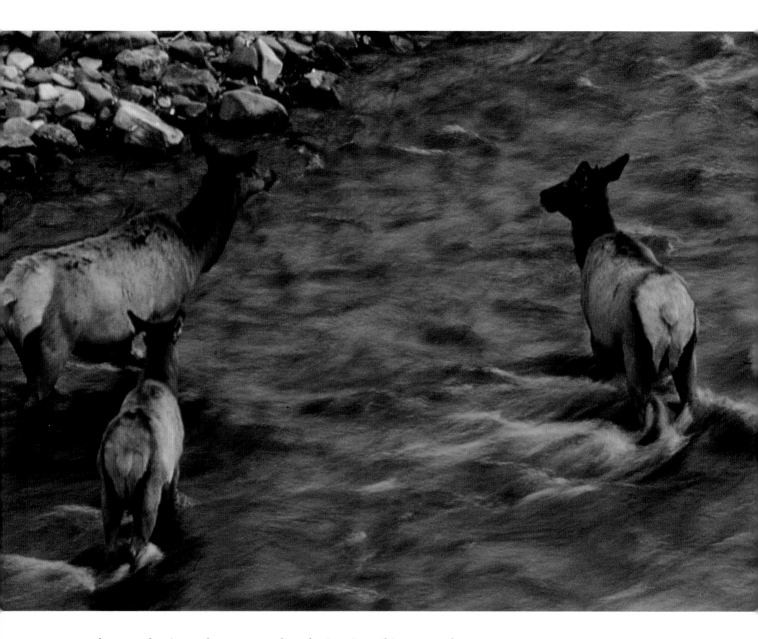

hunts and poisons, the coyote endures by its wits and is respected as a highly intelligent and adaptable animal.

Porcupines amble about with a waddling gait that makes them easy prey. But the cost of a porcupine dinner for a coyote or mountain lion is high, due to its coat of piercing, needle-like quills. The porcupine is a good tree climber and finds sustenance in the bark of spruce and fir trees, which it often girdles to satisfy an appetite.

The red fox is a conspicuous animal whose bushy tail and red markings make it easy to recognize. It lives in mountainous terrain, often on the edge of forests, and doesn't mind close proximity to human populations.

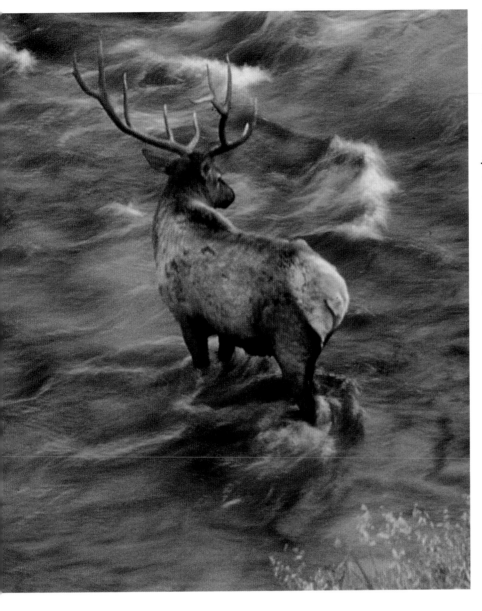

LEFT *Elk, the largest game animals in Colorado, spend the summers at high elevations, wandering timberline ridges and grazing on mountain grasses. Their winter habitat is the south-facing hillsides of lower elevations where temperatures are often mild.*

OVERLEAF *Fly-fishermen are highlighted in the reddish hue of the sun as they pursue gamy trout in the Roaring Fork, one of two Gold Medal rivers in the Aspen area.*

The beaver is a prime example of industry. This hard-working rodent is able to greatly alter the landscape by gnawing trees with sharp teeth and felling them into fast-moving streams. The beaver is considered either a nuisance or the "great conservationist" for slowing erosion and creating lakes and ponds. Their mud-and-stick dams control mountain torrents and their lodges abound in the still water behind the dams.

Biodiversity in nature is hardly an abstract concept when you've seen nature firsthand. From the shrill whistle of a pika and the chattering of a gray squirrel to the serenade of coyotes and the splash of a beaver's tail in a still pond, nature's choir has many voices. And its sound—the harmony of life—is richer for every contribution.

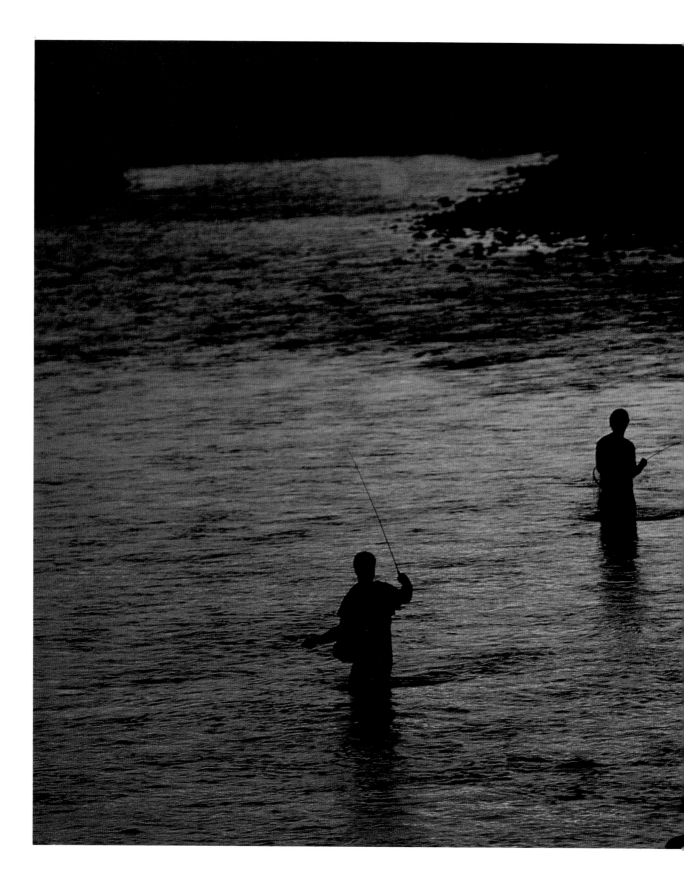

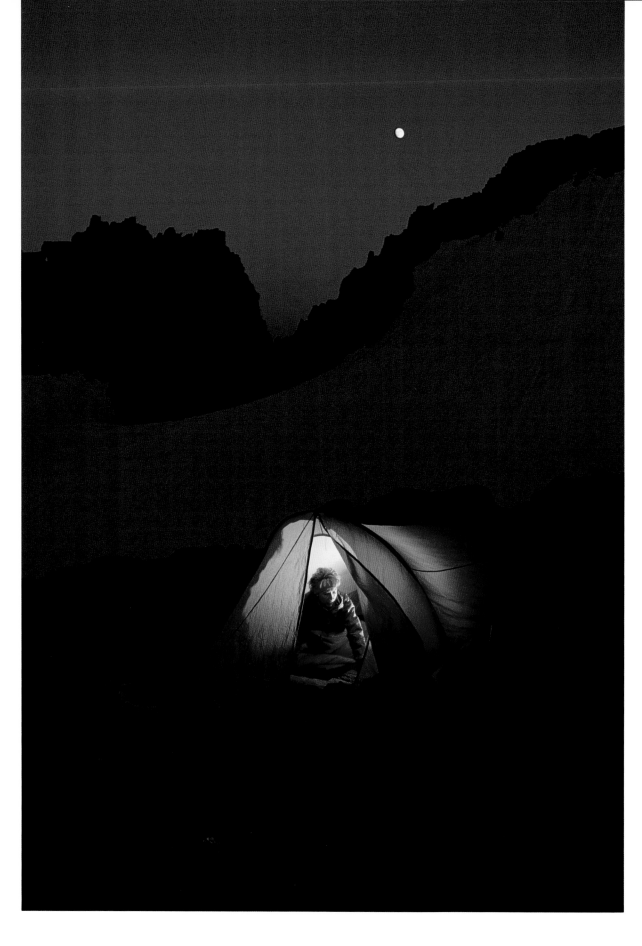

11 Mountain Activities

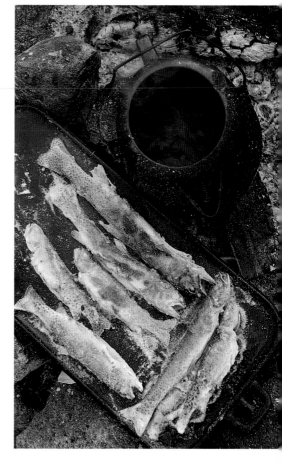

My wife and I hoisted backpacks to our shoulders, cinched tight the waist straps and plodded slowly up a steep trail through a dark conifer forest. Setting out on the narrow dirt track, we soon found a comfortable pace and meshed our rhythmic breathing with the pervasive sound of rushing water from East Snowmass Creek.

Concentrating only on our footfalls, we allowed our senses free reign in deciphering the piney scent of the spruce and fir forest. Our ears caught the sound of cackling ravens and marmot whistles. Our eyes took in the sight of a flicker darting through the conifers. We observed an occasional mountain crest rimmed with a snowy cornice and framed by the flight of fleecy clouds against a deep blue sky.

In the heat of the day we sought the shade of a quaking aspen grove near the creek where a light breeze dried the perspiration from our backs, cool and fresh like a caress from the lingering snowfields high above. We spoke little while eating our sandwiches, our eyes playing over the boulders in the creek, wet from the spray of the splashing water.

Resuming the hike, our legs rebelled for the first few minutes, protesting with lethargy and a dull burn. The trail climbed steeply towards timberline and our pace slowed to a shuffle. The mountains soared up around us as the valley dropped away. Grassy, flower-studded meadows gave way to high alpine tundra speckled with Alpine Forget-Me-Nots. We had yet to see another hiker, but the imprints of lug soles and horse hooves marked the trail along with the deep, pointy grooves made by deer and the occasional, more rounded toe of elk. The shrill whistles of pikas echoed among scree fields studded with columbines.

At the summit of the pass I dropped my pack, wiped my face with a shirt sleeve and waited for my wife. She walked with a determined step several switchbacks below, her head down, arms akimbo, eyes fixed on the rocky track cut into the mountainside. Below, the East Snowmass Creek Valley appeared narrow and confined between steep ridges as it dropped away toward the distant Roaring Fork River Valley.

In Willow Basin we camped on a terrace of soft tundra with a view of Willow Lake. A nearby stream gurgled through a boulder field. The air was cool and dry with a gentle breeze blowing. Wildflowers burst from every square inch of ground, blending into a colorful pallet. We cooked dinner over a sputtering gas stove as the sky turned pink, red and then darkened in shades of deepest purple. We were tucked into warm sleeping bags by the time stars smeared the sky, sleeping with the tent fly open to the night air where a waking glance showed the turning of the heavens.

FACING PAGE *Camping above 13,000 feet requires a weather-tight tent and the endurance to pack it there. A camper prepares for bed under a bright moon near Capitol Peak.*

ABOVE *Small fry trout on the griddle and coffee make one of the best breakfasts in the Rocky Mountains. The fragrance is guaranteed to wake even the most somnambulistic camper.*

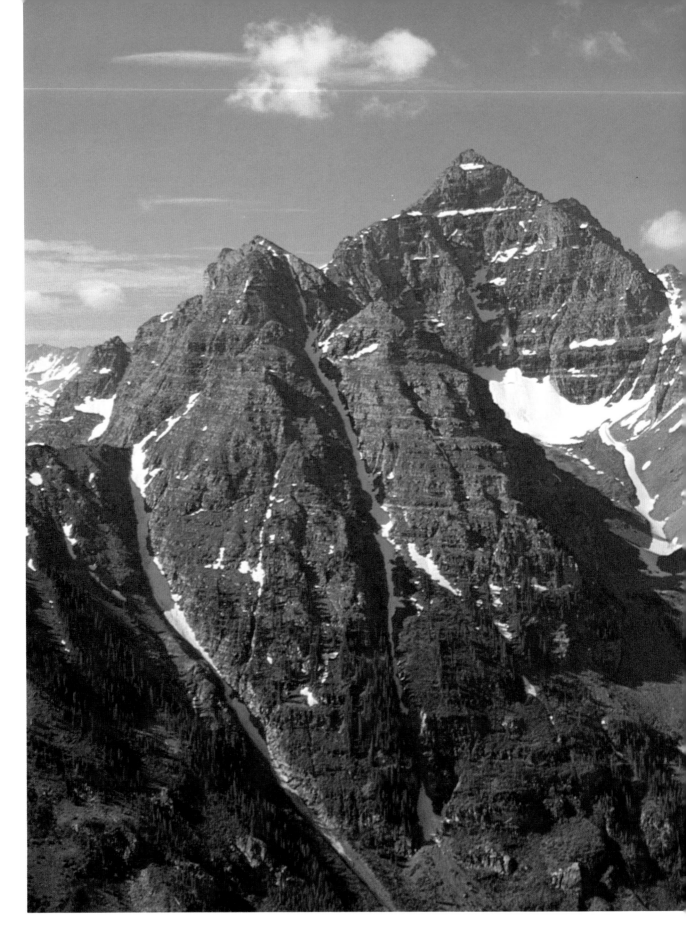

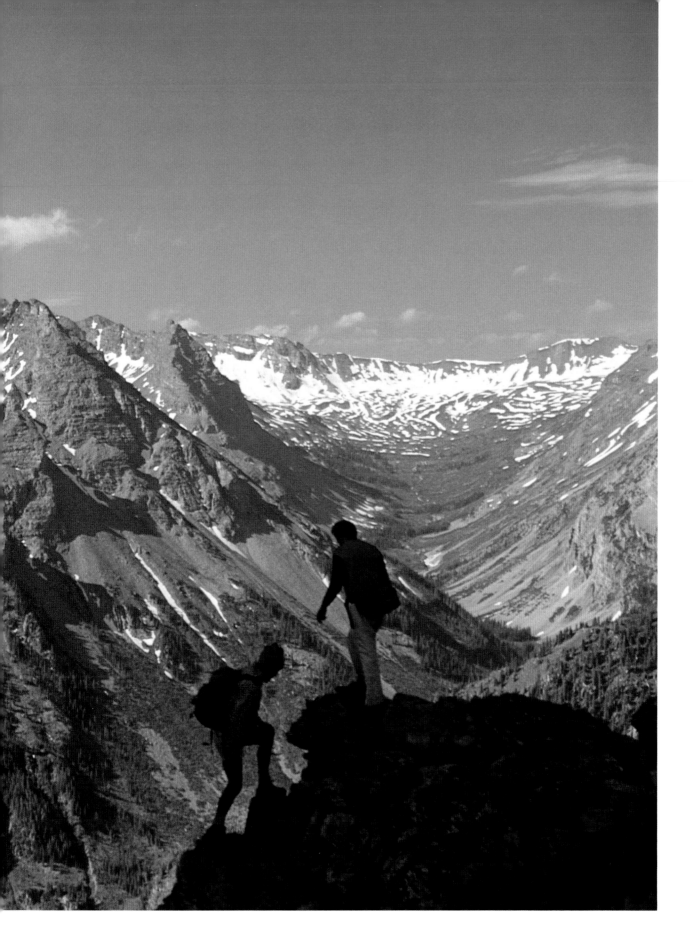

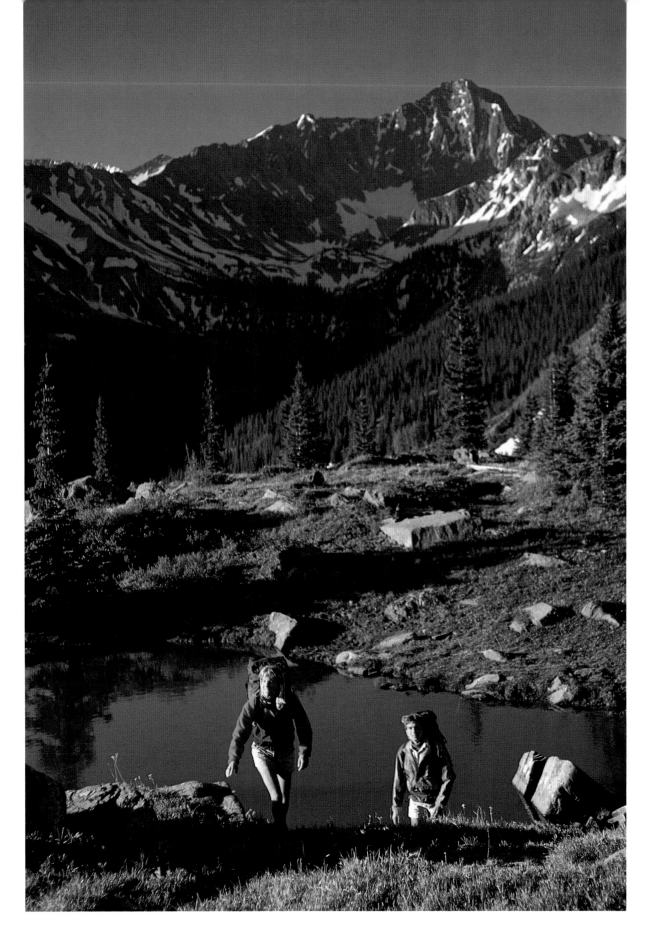

The next day we spent our time with ridge walks and flower hunts, exploring the basin, walking around the lake, taking shelter from an afternoon storm in a thicket of stunted spruce. In the evening we watched from our camp as other backpackers descended the pass and disappeared over the next ridge toward Buckskin Pass and Crater Lake.

On our last morning we dawdled over breakfast and coffee in the still morning air and warm sunshine. But by the time we reached the pass a line of dark, menacing clouds had gathered. We glanced one last time at the basin where Willow Lake held the color of the clouds in a fluid mirror, then headed down to East Snowmass Creek on the steep switchbacks we had ascended two days before. When we were below timberline the storm broke with a violent fury, flashing with barbs of lightning and resounding with deafening thunder that seemed to split the valley in two.

We walked faster now, trying to reach a stand of thick timber for shelter but getting unavoidably soaked. Our feet squished with each soggy step, the rain ran in spouts from the hoods of our rain jackets and we splashed recklessly through puddles and muddy rivulets, enjoying the drenching. When I turned to look at my wife she was walking down the trail through brilliant pink fireweed five feet tall. She smiled through the rain in a picture I will always hold in my mind's eye.

The outdoors are an integral part of the Aspen experience and a prime reason for its rebirth in the late 1940s. A key to Walter Paepcke's "Aspen Idea" was man's communion with nature. And when Albert Schweitzer came to Aspen for the Goethe Bicentennial in 1949 during his one and only visit to America, man and nature struck a profound and harmonious union in Aspen.

PRECEDING PAGE *Hiking and backpacking in the wilderness is the favorite summer experience of local residents and visitors to the Aspen / Snowmass area. These two hikers in the Maroon Creek Valley find a good vantage point to view the grandeur of 14,018-foot Pyramid Peak.*

FACING PAGE *Backpackers ascend a ridge through tundra from a small alpine lake with Capitol Peak filling the horizon against a blue sky.*

LEFT *Three mountain bikers make the strenuous climb up Smuggler Mountain Road, leaving Aspen behind.*

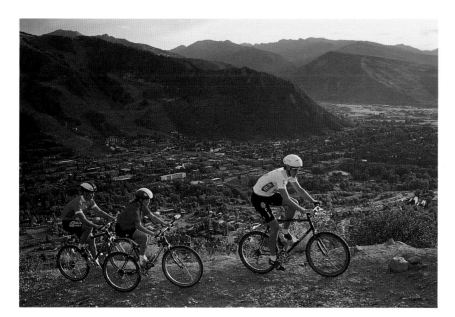

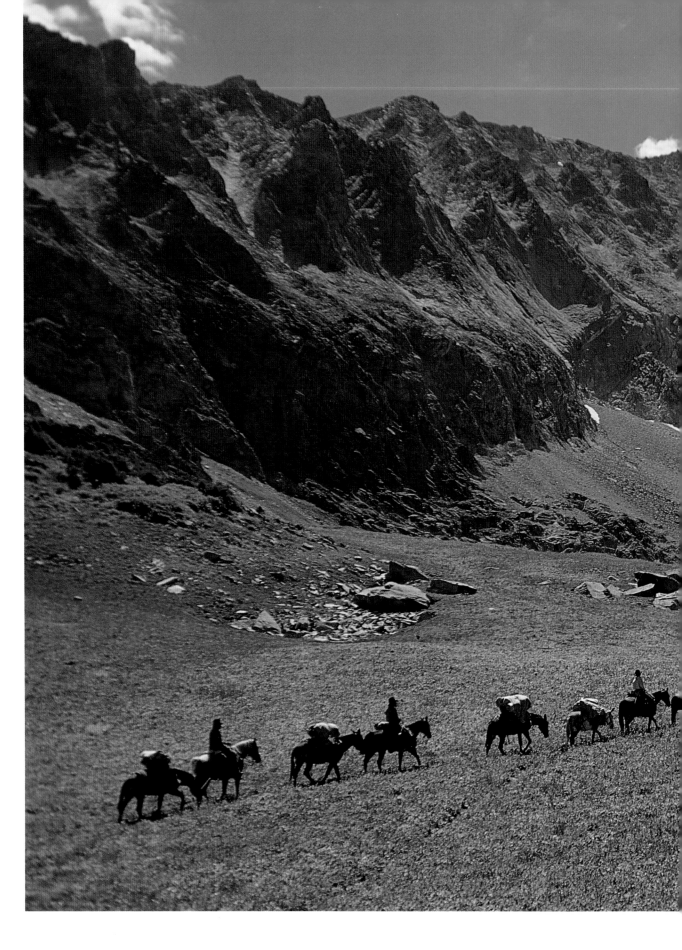

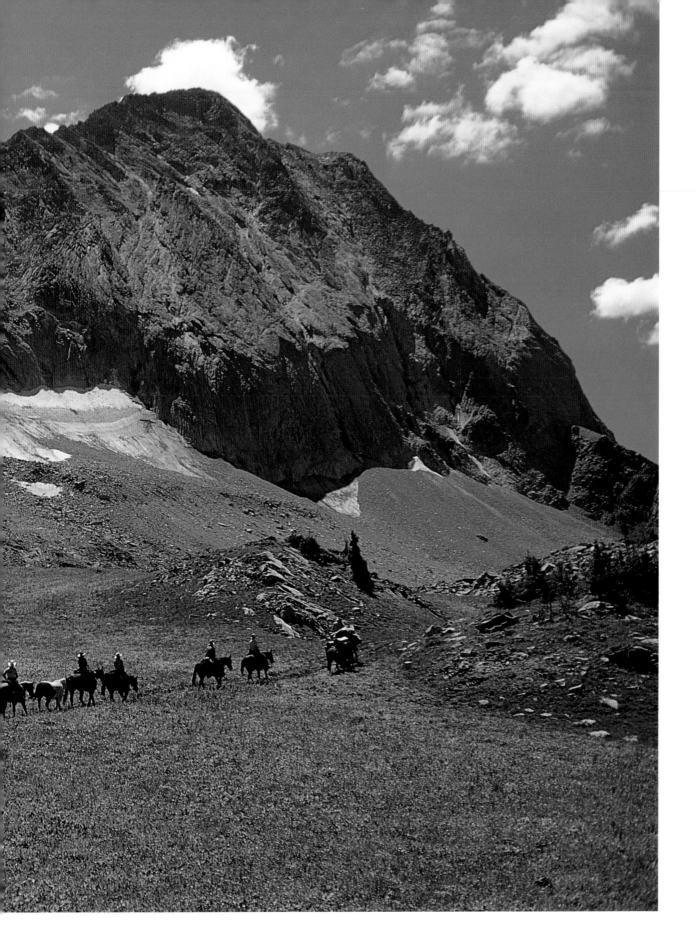

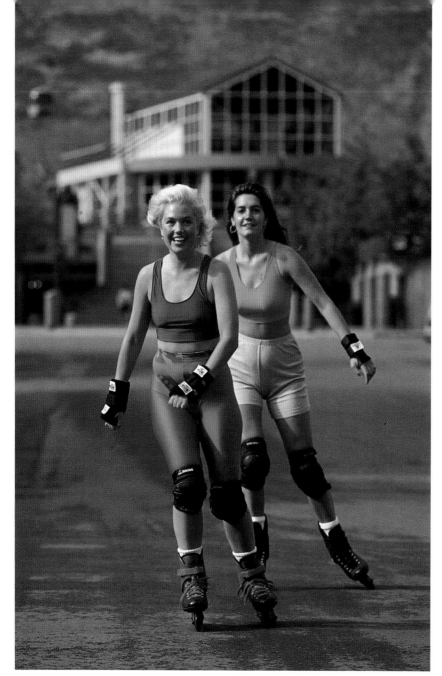

PRECEDING PAGE
A string of horses from Moon Run Outfitters moves up the Capitol Creek Trail in the Maroon Bells-Snowmass Wilderness Area.

LEFT *In-line skating has taken Aspen by storm as one of the trends to win the hearts and work the lungs and legs of well-tuned athletes.*

RIGHT *Adept kayakers run white-water rivers with skill and experience, testing the dynamics created when current plays against stone under the influence of gravity.*

Today the outdoors have become a far greater allure than Paepcke could have imagined. Recreation has become an industry for which Aspen is now a hub. From fly-fishing to parasailing, snowboarding to sleigh rides, rock climbing to roller blading, recreation is one of Aspen's prime missions and a big draw for visitors.

With the Maroon Bells-Snowmass, the Hunter Fryingpan and Collegiate Peaks wilderness areas bordering Aspen on three sides, the opportunities for backpacking, hiking and horseback riding are phenomenal. Whether for a day hike or a several-week-long expedition, the wilderness is a pristine and pure backyard.

The mountains and valleys abound with lakes and streams. The Fryingpan River, 20 miles from Aspen, is a Gold Medal trout stream where

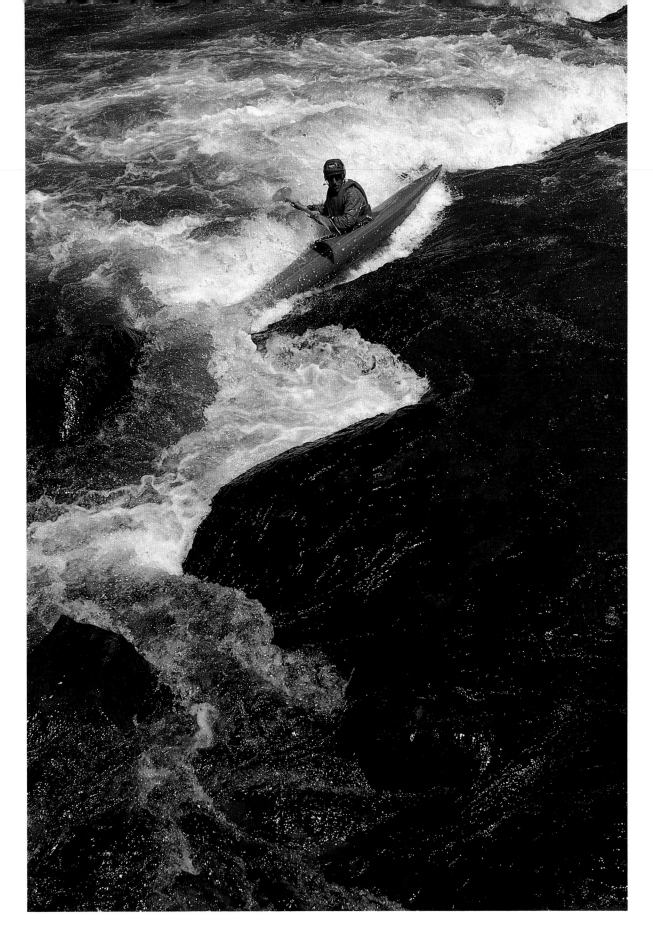

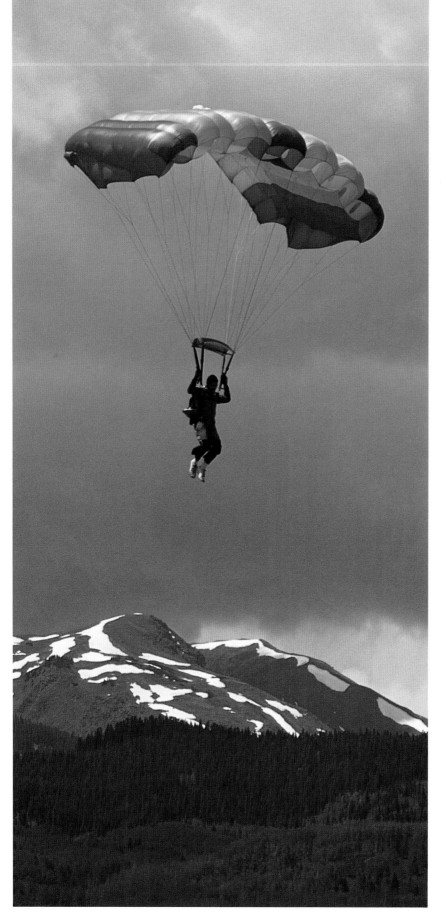

LEFT *A skydiver glides toward a landing after playing in the thermals that create lift from mountain ridges warmed by the sun.*

UPPER RIGHT *Colorful balloons dot the sky during the annual Snowmass Balloon Festival. Balloonists race for prizes while taking in a bird's-eye view above the Snowmass Golf Course.*

LOWER RIGHT *A young cowpoke examines the checkered rudder on a dressy biplane during Aspen's annual Air Show, a convention for daring stunt pilots, skywriters and vintage aircraft.*

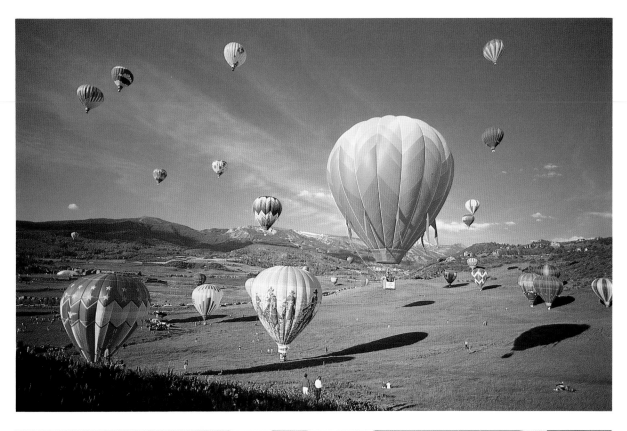

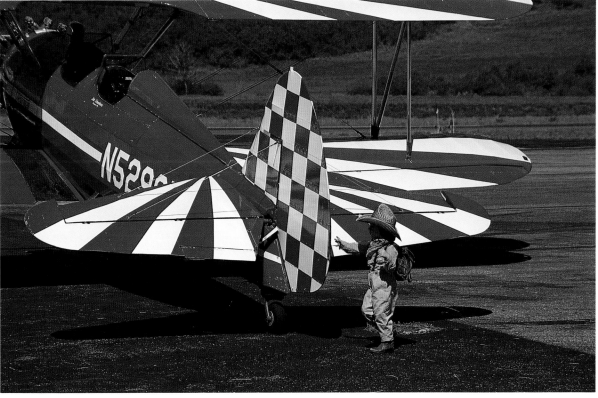

fishermen in hip waders whip the water with long, flexible rods. On the Roaring Fork River kayakers play in the eddies while white-water rafters splash through foamy rapids. High altitude lakes are stocked with rainbows that hit the water for flies and on still evenings leave a pattern of concentric circles on the water's surface.

Mountain biking has become the fastest growing aspect of the bicycle industry in the U.S. In Aspen a major explosion of the sport has taken place. Miles of challenging single-track trails and jeep roads ideally suited for mountain biking traverse conifer forests, aspen groves and high mountain ridges at timberline.

In the summer sky above Aspen parasails and hang gliders drift lazily in the afternoon sun, floating on colorful canopies and swooping down to land in a town park. Soaring planes float noiselessly above the valleys and rush down with a roar over a mountain ridge in search of another thermal. Hot air balloons ascend in the cool morning air with a rush of propane and a jet of blue flame as passengers get a bird's-eye view of the valley below.

The mountain peaks of the Aspen area are famous for their challenge and beauty. Rock climbers practice on the sheer walls and boulders along Independence Pass. Casual summit hikers find their stride on windswept ridges and craggy peaks.

Backcountry skiing through silent meadows and snowy forests, track skiing on an 80-kilometer groomed trail system between Aspen and Snowmass Village, or alpine skiing on the local mountains rounds out the experience on snow. Sleigh rides through Aspen's historic streets in the crisp night air behind a Belgian draft horse jingling with bells lends an old world charm to an otherwise modern resort community.

Snowboarding and in-line skating are the latest trends to hit Aspen. "Shredders" wear outlandish costumes to cruise the ski runs at high speed, speaking a jargon all their own. In-line skaters don form-fitting lycra, protective knee pads and wrist guards to glide wherever the asphalt leads.

Recreation is a consuming passion in Aspen, which is reflected in an equal passion for physical fitness. After all, if you live in a playground, you might as well be fit enough to play the games.

BELOW Dog teams pull a sled from Krabloonik Kennels in Snowmass Village into the winter wilderness while passengers develop an appetite for a midday picnic.

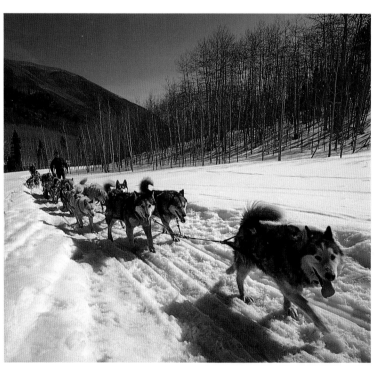

RIGHT A crack-of-dawn start for America's Uphill has hundreds of skiers, snowshoers and runners plodding to the Sundeck atop Aspen Mountain from Little Nell's. This annual event attracts many athletes who are able to make the climb in less than an hour.

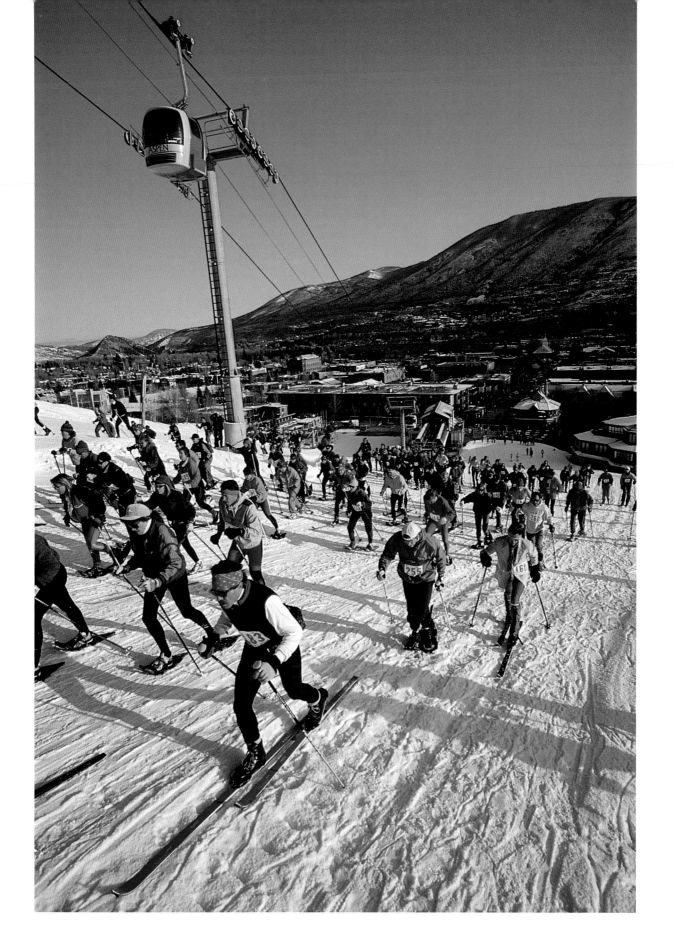

12 Backcountry Huts

Europe was the model for the Tenth Mountain Division Hut System when Aspen architect Fritz Benedict explored the idea decades ago. If the Alps could provide safe, comfortable accommodations for backcountry skiers, so could Colorado. Benedict's dream has come true—the Tenth Mountain Division Hut Association has developed an unrivaled system of ski huts between Vail, Leadville and Aspen.

The first hut built by the Tenth Mountain was a gamble that would either make or break Benedict's plans. The McNamara Hut, named for its sponsor Robert McNamara, was approved by the U.S. Forest Service on the condition that it would be torn down and the site fully revegetated if the hut created any problems with federal public lands policy. But the McNamara Hut proved an instant success and led the way for one of the most extensive hut systems in the country.

Today's Tenth Mountain huts are luxurious mountain lodges built tight and snug with thermal windows, efficient wood-burning stoves, roomy kitchens, spacious bunk rooms with mattresses, and all the cooking gear necessary for groups of up to 16 skiers. The huts are all fitted with photo-voltaic solar panels for clean, safe lighting. Some huts in the system are staffed by full-time hut keepers and several huts have food service and hot tubs.

Before the Tenth Mountain System was created, backcountry skiers had two choices: either limit their travel and stay in one of the six Braun huts between Aspen and Crested Butte, or brave the elements with the rigors of winter camping. The Braun Hut System, established by Aspen pioneer Fred Braun in the 1960s, provided shelter, but the huts were often drafty and ill-equipped.

The Braun huts have been refurbished and are now managed by Tenth Mountain. Also part of the Tenth is the Friends' Hut, a timberline cabin between Aspen and Crested Butte built as a memorial to plane crash victims from both communities who were killed in a head-on crash over East Maroon Pass.

Winter access to the mountains surrounding Aspen has never been better. Routes are selected to avoid most avalanche danger and are clearly

LEFT *Fritz Benedict's dream of a ski trail connecting Aspen and Vail has been realized.*

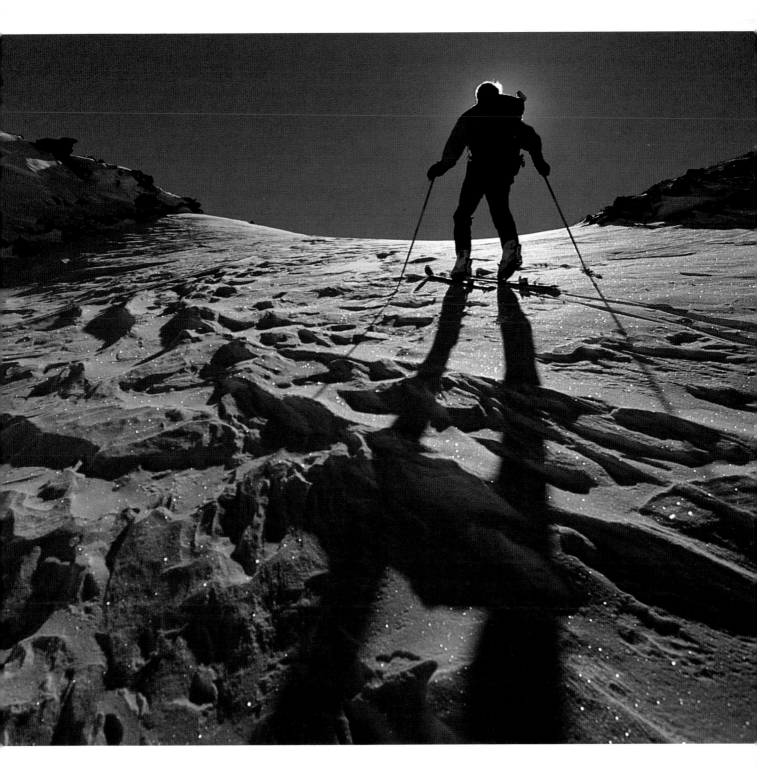

ABOVE *At over 12,000 feet in Pearl Basin a skier makes his way to a ridge of crusty, windblown snow. Going up in these conditions is one thing, but skiing down requires strength and experience.*

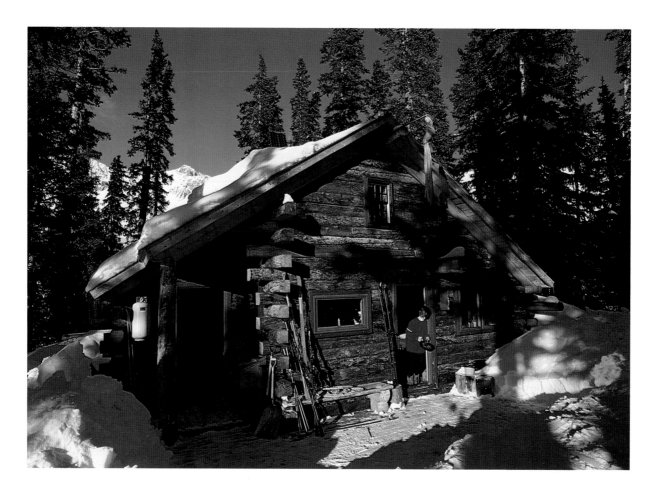

marked for easy reconnoitering. Skiers discover an enduring sense of peace while breaking trail beneath the snowy boughs of spruce forests or gliding through a sunny glade flanked by aspen groves beneath frosted mountain peaks. A sense of camaraderie is inspired by telemark turns on a virgin powder field or sipping tea around a popping wood stove. And the heavens offer a brilliant, starry spectacle on a clear, cold night.

Many of the huts are now open for summer use, ideally suited to mountain bike touring on a network of backcountry logging roads that demand less than top physical condition while affording spectacular mountain vistas. Parents may tow children in bike trailers while support vehicles can carry all provisions.

"If there were a Hilton of backcountry skiing and lodging, Tenth Mountain would qualify," writes Lou Dawson in his Tenth Mountain guidebook. But for anyone fond of rustic mountain living, the huts have the Hiltons beat hands down.

LEFT *The Friends' Hut is one of the most remote mountain getaways in the Elk Mountains.*

RIGHT *Two cross-country skiers enjoy the great winter expanse that is so readily accessible from Aspen.*

FOLLOWING PAGE
The spin of the heavens in time-lapse photography shows the arc of the North Star as if it were a crescent moon over one of the Tenth Mountain ski huts.

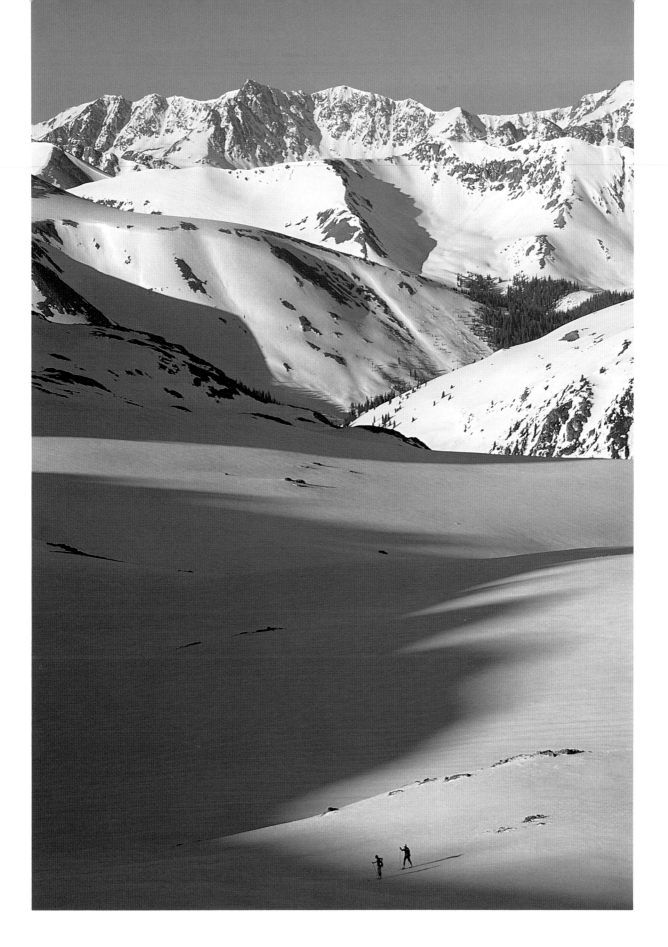

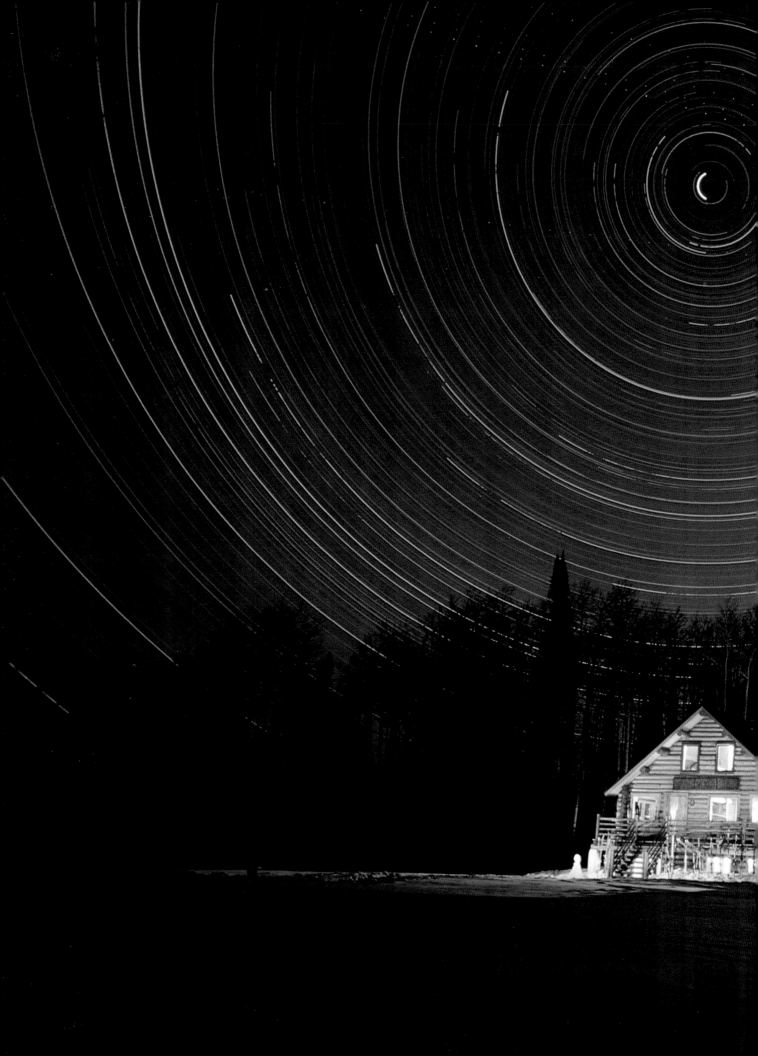

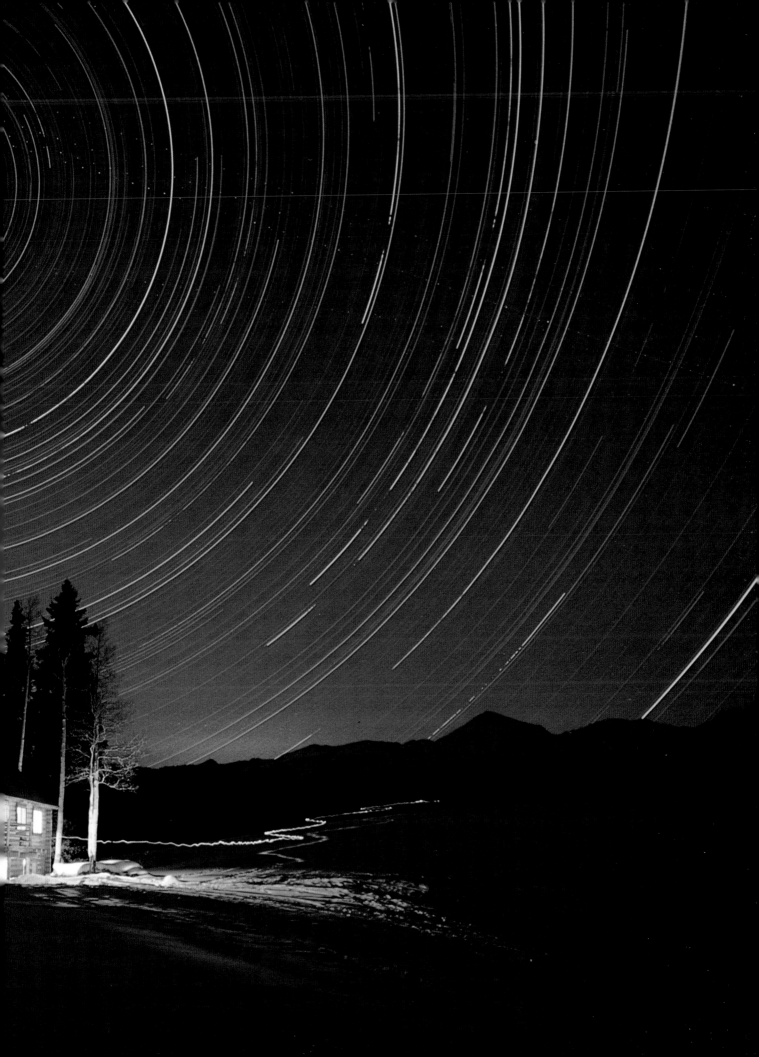

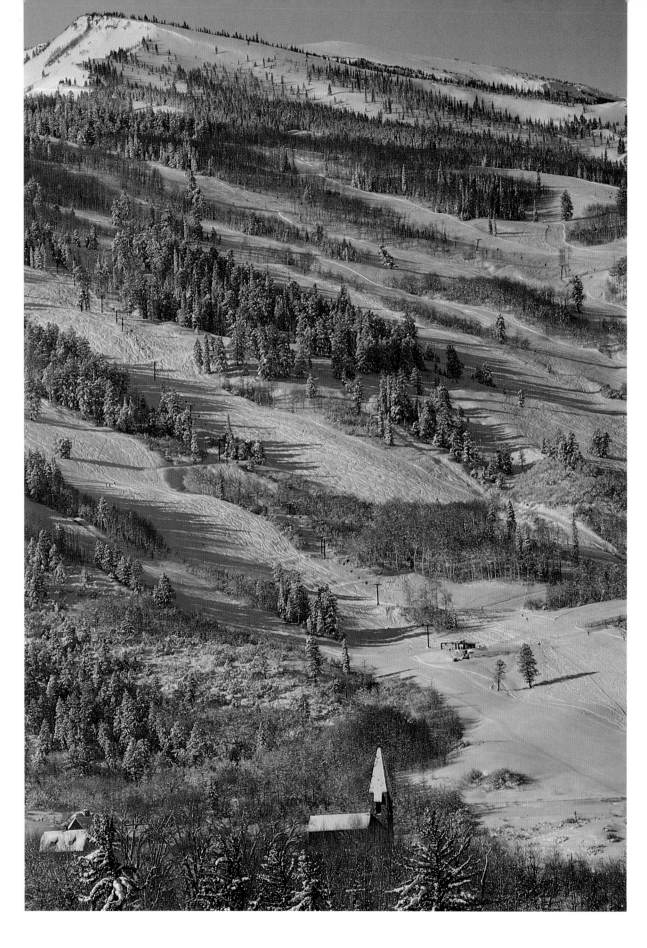

13 Alpine Skiing

Aspen Mountain glistens in the bright morning sun under a fresh mantle of powder snow that squeaks dry and crisp underfoot. Colorado powder is as fluffy as goose down, and for those with the addiction, there is no denying its allure. A half hour before the lifts open, a crowd of powder hounds gathers at the gondola, panting for fresh tracks.

Characterized by its worldwide reputation, Aspen Mountain, or "Ajax" (the name of a former silver mine), has become more than just a ski mountain. It is a barometer for social status and a prime venue for stargazing. Glamour is strutted with the latest ski fashions as celebrities and tycoons flock to one of America's most desired ski areas. Businessmen make deals with cellular phones from the gondola and people come to see and be seen. Where else would The Donald, Ivana and Marla Maples have confronted the tryst of the '90s if not at Bonnie's Restaurant on a blue-sky, midwinter day?

Despite all the gloss and ostentation, Aspen Mountain remains a challenging skier's mountain with leg-burning mogul runs and double black diamond plunges for world-class skiers.

When skiing officially opened in 1947, Aspen Mountain had a single chairlift, billed as the longest in the world at three and a half miles. Chair #1, with its footrest and canvas blanket, took skiers up the mountain with comparative luxury and speed. Prior to 1947 skiers were hauled up the mountain in a long, narrow sled with bench seats by a cable and winch arrangement. The "boat tow" opened in 1938 on Roch Run and served only a small portion of the mountain.

Aspen Mountain was part of a prearranged marriage of cultural, intellectual and athletic pursuits developed as part of Chicago industrialist Walter Paepcke's "Aspen Idea." The Skiing Company was headed by Friedl Pfeifer, a former ski trainer for American soldiers in the Tenth Mountain Division, who became director of the first Aspen Mountain Ski School.

The Roch Cup brought racing to Aspen in 1947, attracting noted skiers from around the world. The first Aspen Mountain FIS World

FACING PAGE *The groomed slopes of Tiehack rise up behind the steeple of the Prince of Peace Chapel. Tiehack derived its name from the railroad "tie-hackers" who harvested lumber from its slopes in the 1880s. The ski area was developed along with Buttermilk in 1958 by Friedl Pfeifer.*

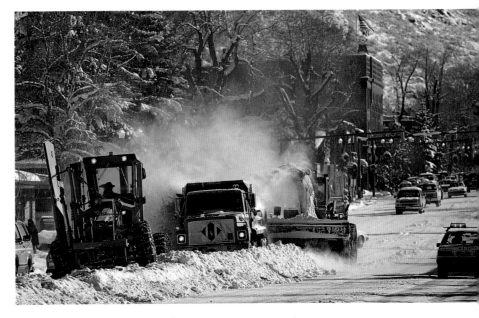

ABOVE *Fresh snow means work for Aspen's road crews, but it bodes well for skiers on Aspen Mountain where the bigger the "dump," the better.*

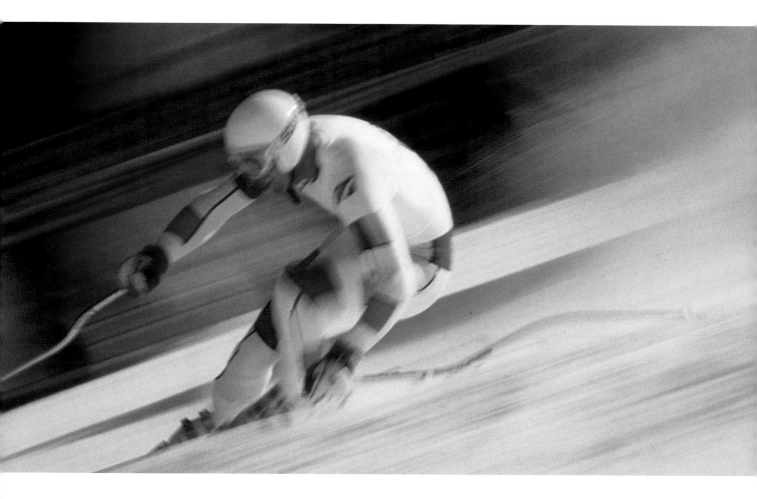

Championships were held in 1950 and drew a field of competitors that could have comprised a "Who's Who of Skiing" for the decade.

Today Aspen's biggest racing event is America's Downhill, the raison d'être for Winternational, a gala midwinter celebration of skiing that infuses Aspen with a festive spirit and an international community. Race teams dine in local restaurants and love to belt out boisterous national anthems in Italian, French and German.

On race day competitors gather in a corral at the start, cordoned off behind a flimsy fence of red nylon streamers. In the early morning sun, they stretch their well-muscled bodies, shake out their limbs with a jig-like dance, and cajole one another with light banter.

The racers snap into extra long skis with low shovel tips and specially tuned bottoms, throw off their jackets and pull on helmets and goggles. Curved, aerodynamic poles in hand, they take several deep breaths while the starter gives the count. At the appointed moment the skier pushes off, skating frantically from the starting gate to begin a mad, downhill dash, plummeting at over 70 miles per hour in a tight tuck toward the bottom of Aspen Mountain.

ABOVE *A downhill racer flashes through the America's Downhill race course on Aspen Mountain, reaching speeds in excess of 70 miles per hour while negotiating rutted, icy courses and vertical plunges.*

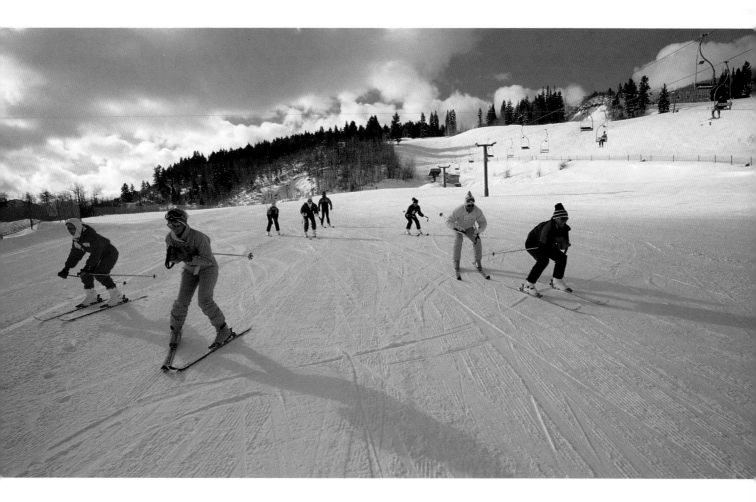

The Downhill is a delightful blur. Its field has included ski stars like Phil Mahre, Peter Mueller and Ingemar Stenmark, who flash down a demanding course followed with a chorus of cheers and the traditional clanging of cowbells. In a tight tuck, skis edged for a turn, concentration finely honed, a downhill racer bursts into view for only a moment before disappearing over a rise, held tight in the clutches of gravity.

For the nonracer, skiing can provide much the same level of excitement a downhiller feels, and hence its popularity. Paepcke's Aspen Idea helped bring skiing to Aspen, but skiing has become the town's greatest identity, with Aspen Mountain as the cornerstone. A high-speed gondola carries six passengers from bottom to top in 15 minutes and a high-speed quad at midway whisks skiers to the Sundeck faster than dinner plans can be made. Snowcat powder tours on the ridge behind the Sundeck give a taste of powder in untracked glades and basins. The development of three other mountains in the Aspen area followed to keep pace with the soaring popularity of skiing. Booming tourism demanded new terrain and there was plenty to choose from in the Roaring Fork Valley.

ABOVE *Beginner skiers are just as challenged as the experts as they learn the basics of skiing at the Vic Braden Ski College at Buttermilk.*

OVERLEAF *The high-speed gondola on Aspen Mountain takes six skiers at a time from bottom to top in about 15 minutes. Aspen Mountain remains the flagship of the four Aspen ski areas.*

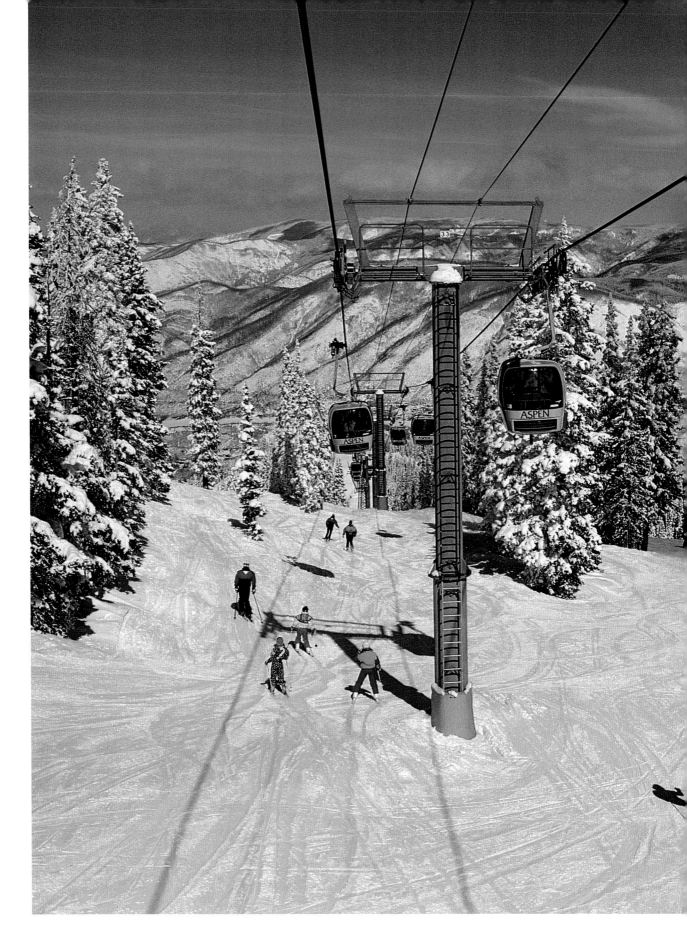

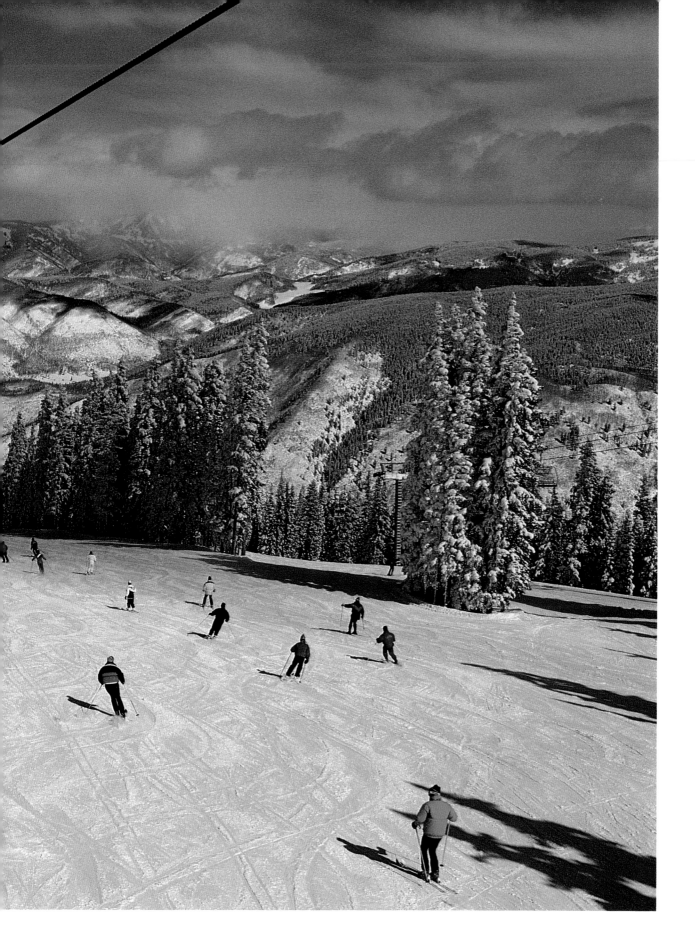

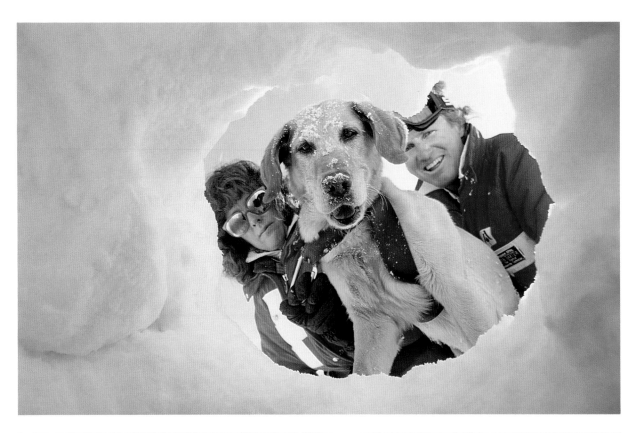

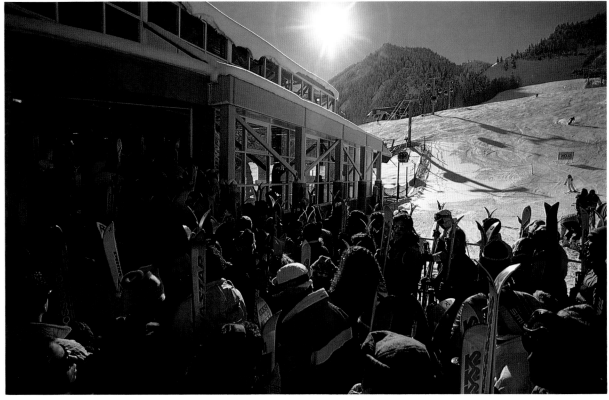

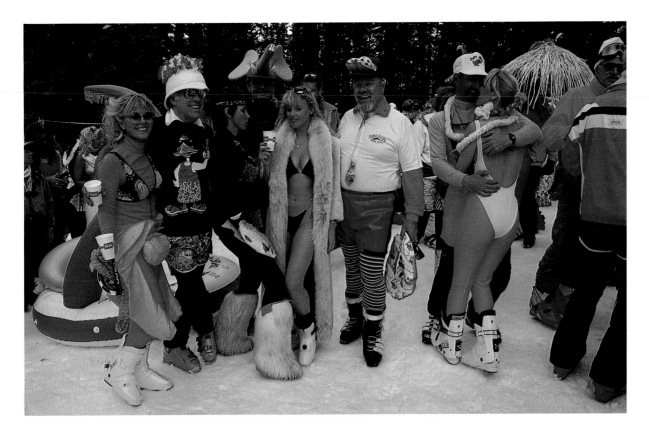

Buttermilk/Tiehack, a smaller and more intimate area developed by Friedl Pfeifer in 1958, is appreciated for excellent grooming, popular racing programs and a quiet atmosphere. Buttermilk is also well suited to a growing number of uphillers, the fitness freaks who swarm the slopes on snowshoes and skis equipped with climbing skins for a pilgrimage to the Cliffhouse Restaurant and the reward of delicious bread pudding.

Aspen Highlands is the only independent ski area, opened during the 1958-59 season with Norwegian skiing legend Stein Eriksen heading its ski school. Highlands, a family-owned ski area, retains a funky, laid-back charm and some of the most demanding skiing of all the mountains.

Snowmass is the most recent addition, opened in 1967 by the Aspen Skiing Company to relieve pressure on Aspen Mountain and Buttermilk. Snowmass is one of the biggest destination ski resorts in the country, spanning 2,500 acres with 14 lifts, including three high-speed quads. Designed on the premise that skiing should be open and uncrowded, Snowmass lives up to that expectation.

From the Sundeck on Aspen Mountain, at 11,212 feet, a panorama of the Elk Mountains is a stunning reminder that beyond the four ski areas lies a dramatic range of rugged wilderness. This scenic beauty and the thrill of skiing laid the foundation for the Aspen of today.

UPPER LEFT *Chopper, the avalanche rescue dog, peers into a hole in search of a victim during a simulated avalanche drill. Chopper works with the Aspen Mountain Ski Patrol by lending his keen sense of smell.*

LOWER LEFT *Crowds pack the gondola at the base of Little Nell on Aspen Mountain for the first run of the day*

ABOVE *A slopeside party on Aspen Mountain panders to the resort's image as a socialite's dream.*

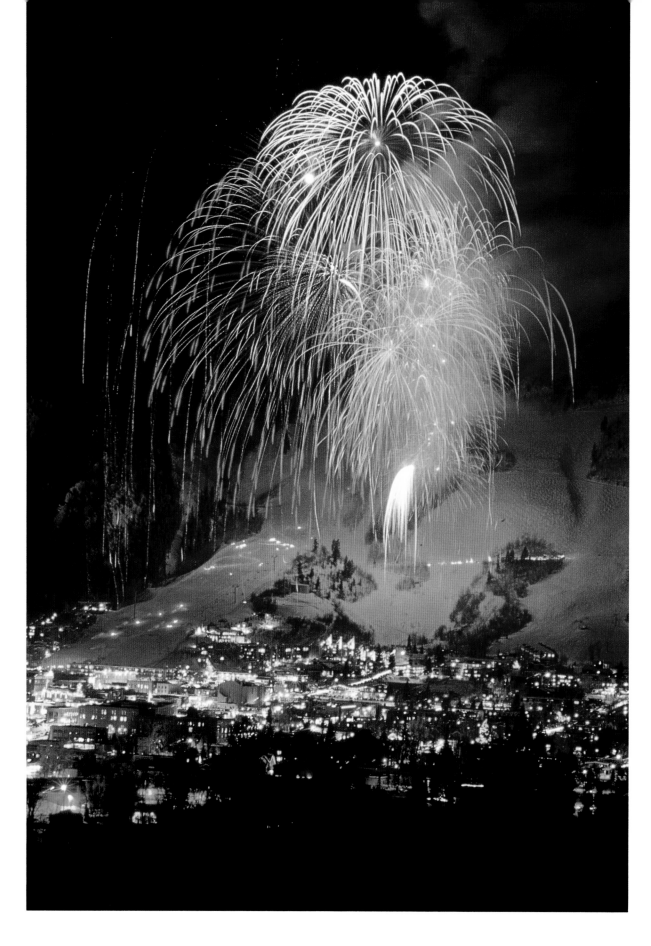

14 The Town

The silver dome of the century-old Elk's Building glows in the slanting rays of sunset while floodlights illuminate the display windows of the Esprit clothing store on its first floor. Draft horses and buggies wait for fares outside the 100-year-old Independence Square Building while shoppers browse the racks of the Banana Republic store inside.

The core of Aspen's downtown represents striking cultural and historic dichotomies blended in a unique contrast of eras. Victorian buildings from the mining days of the 1880s create an authentic historic atmosphere while stretch limos serve the elite clientele of one of the most sought after, contemporary, high-priced resorts in America.

Aspen is a National Historic District with a tony, contemporary ambiance sometimes compared to Disneyland. The Victorian window dressing represents a facade, much like the false fronts that lined Main Streets in the 1880s. One of the most startling realizations for many Aspen visitors is that people actually live in Aspen year round working full-time jobs, raising families and functioning as part of a living and vibrant community. Despite its image as one of America's most posh international resorts, Aspen is still a small town.

Living in a storybook village at 8,000 feet in the Colorado Rockies imparts a sense of fantasy because Aspen has attained almost mythical proportions as a modern day Shangri-la. But the more intimate one becomes with Aspen, the less convincing the myth becomes. Air pollution, crime, the lack of affordable housing and endless political bickering are intractable aspects of the real world. If one can ignore the shortfalls, however, or at least accept them, the myth survives. The natural setting has something to do with softening the exigencies of life and most residents cannot help but exhibit a sense of hubris for the place they call home.

When winter snow is piled up on the streets, draping the trees and

benches on the downtown mall with soft, white pillows, Aspen is subdued with a hushed silence, as if the air itself were muted. Snow filters down from a dense, gray sky of low-hanging clouds and pedestrians turn their collars against the weather, white plumes of vapor issuing with each breath.

Cars bustle about on icy roads, competing with horse-drawn sleighs decorated with shiny harnesses and jingling bells. Skiers trudge to and from the slopes, skis balanced on their shoulders. Bicycle riders clad in boots and winter parkas pedal through snow and slush. Fur-clad shoppers browse storefronts or push shopping carts in local grocery stores.

Summertime brings long, mild evenings conducive for strolling beneath aspen trees on the mall. Bright flowers add an air of festivity to the scene and the fountains attract boisterous children who play in the

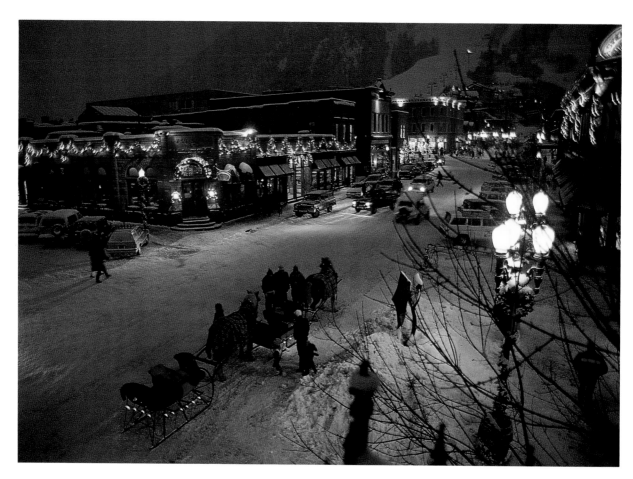

ABOVE *Lights cast a rich glow in the snow of a winter night on the Hyman Avenue Mall.*

water until their parents drag them away soaking wet and disappointed that summertime doesn't last forever. Street performers turn the mall into an impromptu circus, where crowds cheer fire juggling, balancing acts and sleight of hand. Street musicians fill the air with the sounds of string quartets, brass ensembles and bluegrass banjo and guitars.

Specialty chocolate shops, European bakeries, posh art galleries, clothing boutiques and gift stores conduct a brisk, lucrative trade. So exclusive have the shops become that a popular lament from local residents is that one can no longer find socks and underwear in Aspen.

History has been kind to Aspen by providing the backdrop of Victorian buildings that create its unique atmosphere. The gingerbread facades of artfully refurbished buildings provide an aesthetic grace and a compelling sense of history. Behind the facades is a community struggling

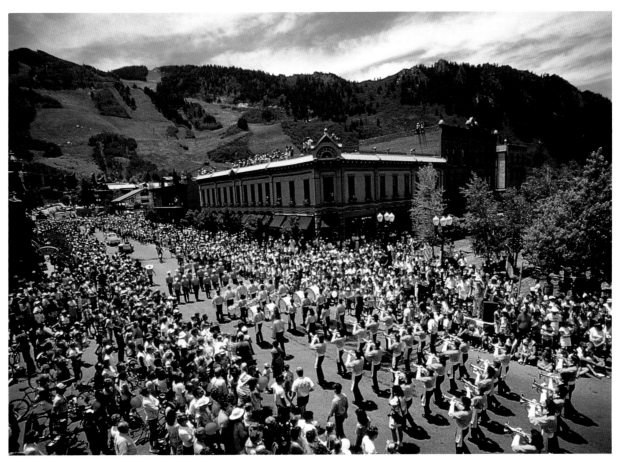

ABOVE *The Fourth of July parade fills the streets of Aspen with marching bands and floats.*

through an often tumultuous political process to preserve and maintain the Aspen experience.

The city retains a comfortable scale because of strong growth controls. Building regulations comply with strict criteria for designation as a National Historic District. Preservation is a powerful word in Aspen, where all new construction and renovations are scrupulously judged by an appointed board that serves at the pleasure of the city council.

But today's Aspen is more than gingerbread filigree and jugglers. Each year Aspen produces a calendar crowded with events and activities, some originating from tradition, others intended to prime the pump of tourism.

Rugby players clash like Titans on the field of battle at Wagner Park in an autumnal display of testosterone that draws hundreds of fans. The "Gentlemen of Aspen" take on the toughest rugby players in the region, usually coming out on top. On the other side of the spectrum, the Food & Wine Classic draws food critics, wine connoisseurs and the world's top chefs, who create and savor culinary delights beneath tent canopies. Ruggers are renowned for consuming vast quantities of beer and bratwurst. Connoisseurs sip vintage vino and pamper themselves on pâté.

Aerial weekend and the Snowmass Balloon Festival keep eyes skyward as vintage aircraft ply the heavens, streaking through the blue Colorado sky in formation or skywriting in serpentine vapor trails. Hot air balloons hiss and roar overhead as they shoot jets of flame into their colorful canopies, rising in the still, cool air at sunrise.

ABOVE *Aspen night life is one of the big attractions for a youthful population that lives to party. The town has a number of popular disco bars that rock until 2 a.m.*

RIGHT *The Hyman Avenue fountain is a big hit with children who find refreshment on a summer day dashing through jets of water which are programmed to shoot up in a completely random pattern.*

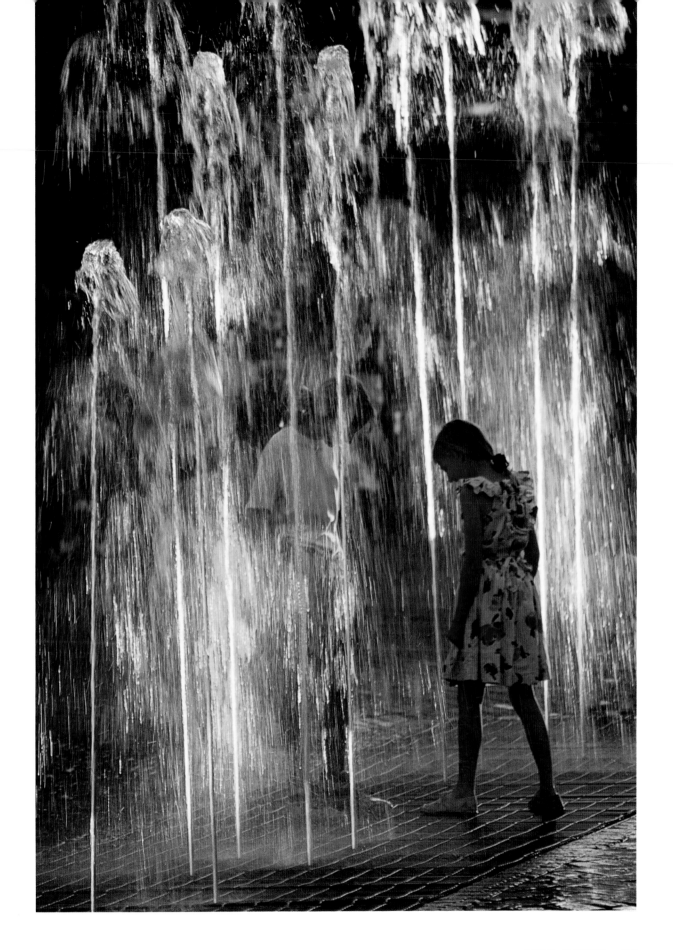

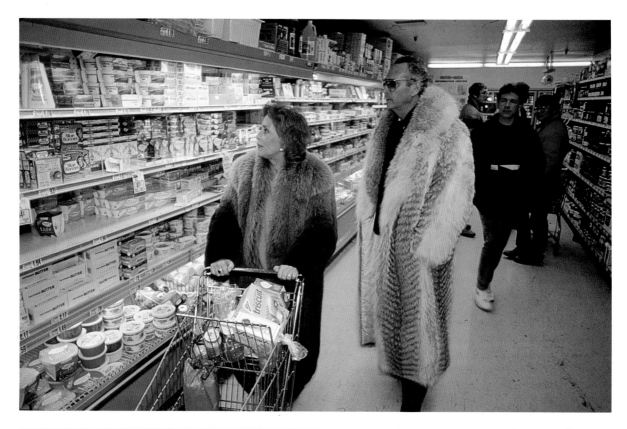

FACING PAGE TOP
Shopping for groceries in Aspen can be a dressy affair. His-and-her furs are de rigueur for a segment of the upper crust.

FACING PAGE BOTTOM
Margaritas and Mexican food make La Cocina one of Aspen's most popular restaurants. Aspen has a well-deserved reputation for cuisine of any nationality.

LEFT *Aspen's café society has spread to a number of specialty coffee and dessert shops. Pour la France! is one of the town's most popular, long-standing eateries.*

One summer Aspen hosted nearly 1,000 motorcyclists riding deluxe Honda Gold Wings who called themselves the "Wing Dingers." Another year thousands of cyclists pedaled through Aspen and over Independence Pass on a "Ride the Rockies" tour. In 1990, the Aspen Institute brought President George Bush and British Prime Minister Margaret Thatcher in a visit that generated political demonstrations, flag flying, and a noted presence by the Secret Service.

A New Age offshoot that fields a unique group of avant-garde followers is the Windstar Choices for the Future Symposium. This annual gathering introduces concepts in living and philosophy from activists like Jeremy Rifkin, Dennis Weaver, Jeanne Houston, John Bradshaw and Windstar Founder John Denver.

In the fall, "leaf-peepers" arrive in droves to oggle the yellow-gold aspen trees in the crisp days of autumn when early snow frosts the mountain peaks a dazzling white. Mountain bikers, jeepers, campers and hikers head for the high country for a visual feast from nature's paint brush.

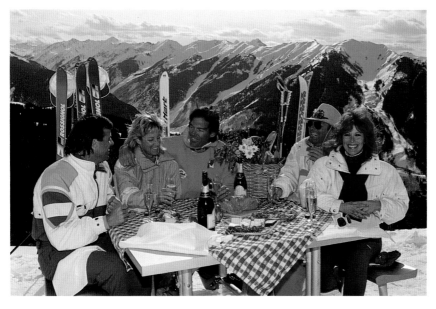

Winterskol and Winternational highlight Aspen's ski season in an annual celebration of snow and skiing with fireworks, ski races and parades. The Aspen Filmfest adds a flare for cinematic expression and a fix for popcorn junkies who watch feature after feature in a movie marathon of the latest domestic and foreign films.

Aspen is an unusual place with a mood all its own, where the daring dreams of early miners are contrasted with the diverse values and opulence of contemporary society. Aspen is a commercial center of glitter and glamour, a venue for theatre, art and the intellect, a polished modern community with small town values and roots that are firmly anchored in the rich loam of history.

Celebrities have given Aspen a reputation as one of the glitter capitals of the world, a place where Danny Sullivan, Chris Evert, Andy Mill, Billy Kidd and Jill St. John picnic at the Sundeck, Jack Nicholson enjoys a beer, Hunter Thompson takes on the court system, and John Denver leads his New Age disciples.

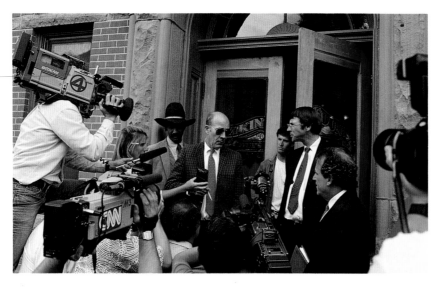

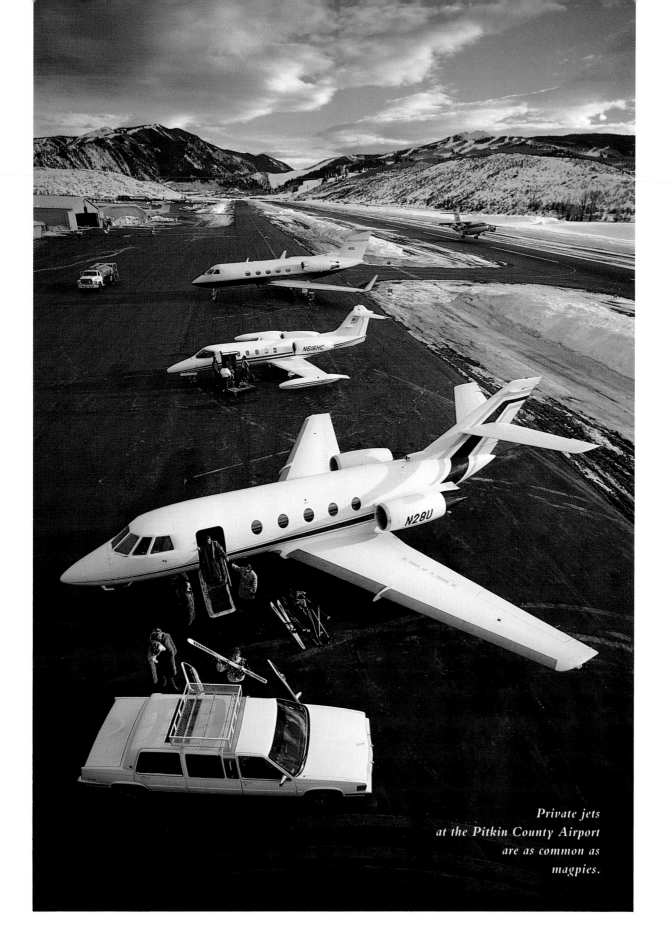

*Private jets
at the Pitkin County Airport
are as common as
magpies.*

15 Culture & the Arts

Young Sarah Chang stands poised and controlled on the stage of the Aspen Music Tent alongside the great violinist, Pinchas Zukerman. She beams an uncontrollable smile and bows with a demure shyness that brings a din of cheers, shouts and whistles from a moved audience.

Sarah Chang is no ordinary little girl. She is a violin virtuoso who has visited Aspen every summer since early childhood to perform with the Aspen Music Festival. Her presence on stage with an established superstar is what the Festival is all about.

The Aspen Music Festival grew out of the Aspen Idea, the brain child of Chicago industrialist Walter Paepcke, who infused the town with its artistic and intellectual identity in the late 1940s. For every year since then the Festival has fielded the greatest musical talent in the world to perform beneath the Music Tent and has staffed one of the top music schools in the country.

Each summer a nine-week concert program invigorates Aspen with Classical music and a plethora of students arrive from the best music schools in the country to play in three separate orchestras. On summer days, Aspen is alive with the violins, flutes, pianos and bassoons of rehearsing students. And during mild evenings on the mall, students form impromptu quartets and quintets to perform for tips when they're not playing for an opera at the Wheeler Opera House or under the baton of a visiting maestro at the Music Tent.

Music is foremost among many artistic endeavors that grace Aspen with a wealth of culture rare for a small mountain community. The arts in Aspen remain vital, with dance, music, sculpture, painting, theatre and photography.

At the Aspen Art Museum, a handsome brick building on the Roaring Fork River, exhibits of sculpture, photography, painting and regular shows featuring local artists have created strong community support and involvement. Stroll through Aspen's business district and the many galleries exhibit a broad variety of artwork, from quirky animal sculptures at the Tavelli Gallery by Angelico and Manuel Jimenez, to the realism of

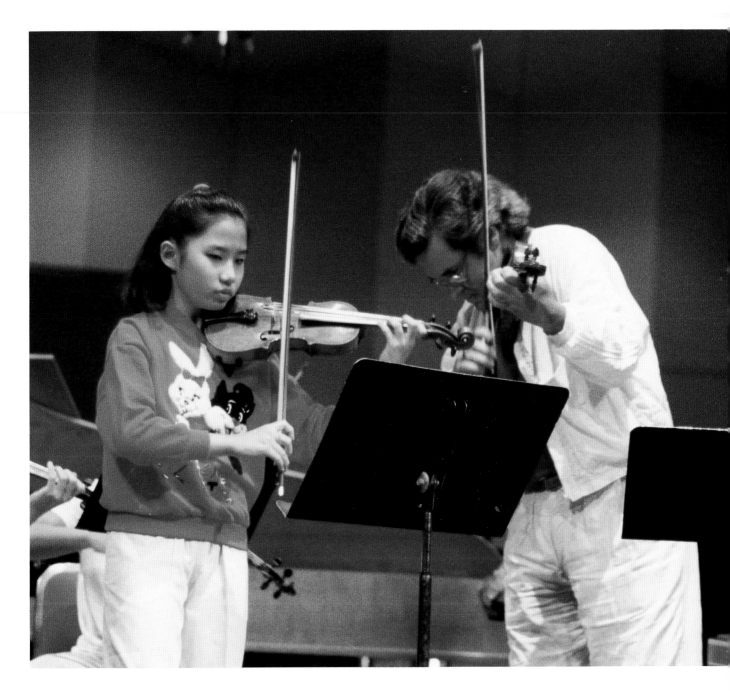

landscapes painted by the Yugoslavian artist Zvonimir Mihanovic at the E.S. Lawrence Gallery.

In Snowmass Village, Anderson Ranch is a collection of rustic buildings from a homesteaded ranch 100 years old. Today it is a training ground for art students who convene to paint, work with wood, photograph and sculpt with talented instructors. Visiting teachers provide a broad scope for Anderson Ranch and have helped boost it to prominence as a renowned art center.

OVERLEAF *The Aspen Music Tent is the focal point of the Aspen Music Festival where performances are given daily during an active summer season.*

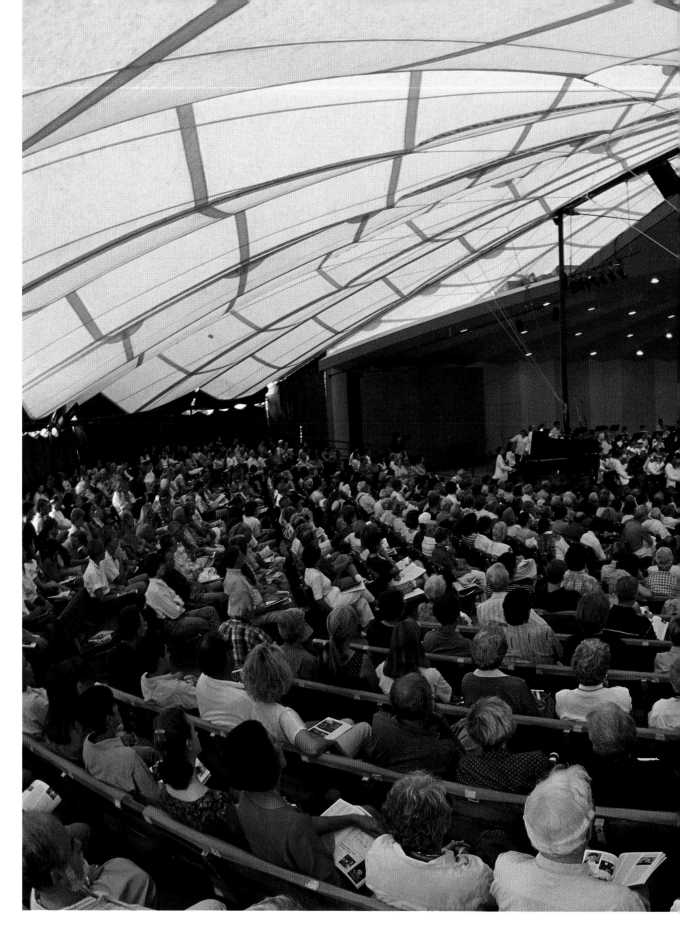

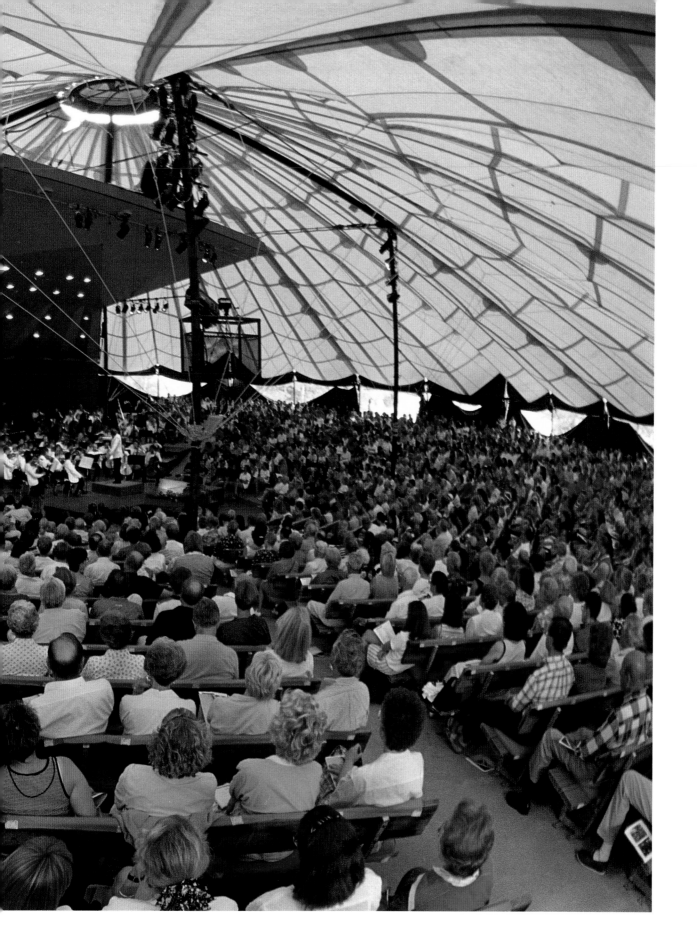

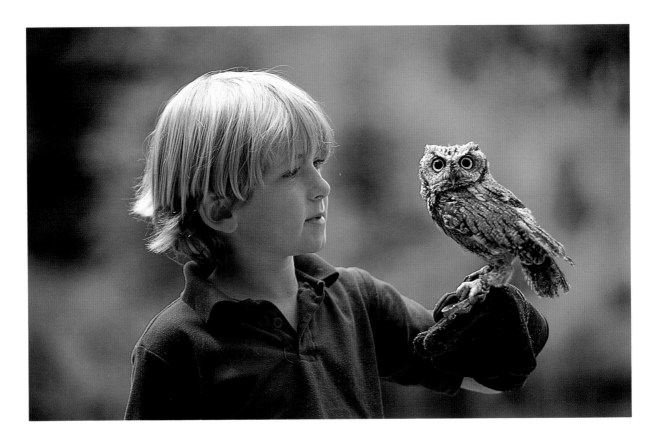

In performance art, DanceAspen and the Aspen Theater Company draw actors and dancers for summer-long programs. DanceAspen brings troupes like the Parsons Dance Company, the Paul Taylor Dance Company and the Miami City Ballet to perform classical ballet and modern dance. The Aspen Theatre Company holds dramatic performances in a tent by the Roaring Fork River.

Jazz Aspen, born in 1991 in honor of a strong jazz tradition that flavored Aspen in the '50s and '60s, features ballroom dancing in the Hotel Jerome, big name acts in the Aspen Music Tent and open air jazz in the park. Dave Grusin, Ernie Watts, Dianne Schurr, Nancy Wilson and the Count Basie Orchestra are only a few of the visiting performers.

Aspen has been called the Sante Fe of the Rockies, an acknowledgment of its artistic appreciation and continued cultivation of the fine arts. Self-expression is alive and well and offers a valued facet to a community that champions the freedom to create.

The International Design Conference provokes thought by enjoining the world's creative thinkers and designers in a contemplation of society. The Aspen Institute for Humanistic Studies, Aspen's intellectual cornerstone, offers summer-long seminar programs with public lectures by philosophers, physicists and cabinet-level officials. President George Bush and British Prime Minister Margaret Thatcher visited Aspen in 1990 to be

ABOVE *Will Cardamone examines an owl first hand at the Aspen Center for Environmental Studies at Hallam Lake.*

UPPER RIGHT *A sculpture made of car bumpers stands atop the public parking garage in downtown Aspen, softened by a layer of fresh, white snow.*

LOWER RIGHT *A dance rehearsal prepares ballerinas for the stage during DanceAspen's summer program, in which young dancers learn from masters.*

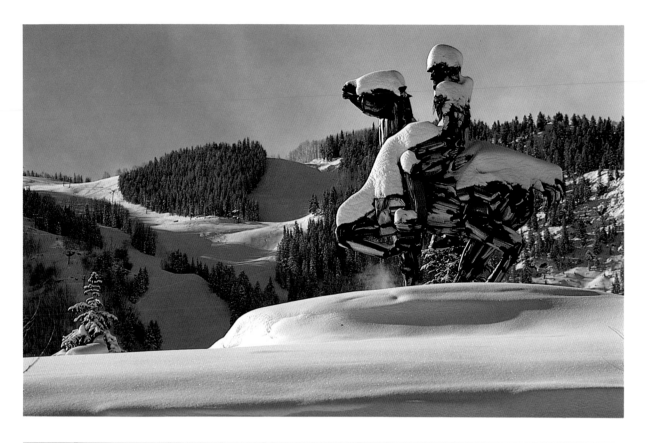

honored by the Institute just prior to the outbreak of hostilities in the Persian Gulf that resulted in Operation Desert Storm. Numerous other top administrators and national political figures have added an international perspective to the Aspen experience by bringing their views and expertise and sharing them with the public at free lectures. The Aspen Center for Physics gives talks on quarks, black holes and string theory from their "circle of serenity" on the Meadows campus.

The Aspen Institute was the focus of founder Walter Paepcke's Aspen Idea. Paepcke's vision called for a meeting ground for corporate, government and academic interests that would flourish more fully when blended with the beauty of nature and the athletic challenges nature provides with skiing and hiking.

"Where man's creativity is honored," said Paepcke, "nature's handiwork is also cherished." The natural environment is one of Aspen's

most valuable features and the Aspen Center for Environmental Studies (ACES) is a treasured resource.

Elizabeth Paepcke founded ACES at Hallam Lake to afford the opportunity to study nature in a sheltered setting. During the mining heydays of the 1880s, Hallam Lake served as a playground and amusement park where boats were rented and dances were held in a lakeside pavilion. The lake also yielded a harvest of ice for preserving the miners' food.

ACES was incorporated as a wildlife sanctuary in 1968 with a mission statement to preserve Hallam Lake's ecological diversity. The six-acre lake and 16 acres of marsh and riparian habitat provide a unique setting ideally suited for observing, studying and appreciating nature. Programs include self-guided tours of the lake and marsh, school programs for all ages, adult field school classes, guided nature walks of the Aspen area, snowshoe walks during winter and a free community slide show series from local travelers.

Aspen's cultural experience spans from the natural world to the fount of human creativity, both of which thrive here relatively unfettered. In this rare atmosphere, people often discover in themselves a connection to art and nature that is conducive both to self-expression and learning. Paepcke's Aspen Idea is alive and well.

ABOVE *Molly Favor works on a triptych of the Elk Mountains in her Anderson Ranch studio. The "Ranch," an arts center at Snowmass Village, has an international reputation.*

OVERLEAF *Photography is one of the most popular activities in the Aspen area, where the natural beauty draws tourists and photographers, professional and amateur, from all over the world.*

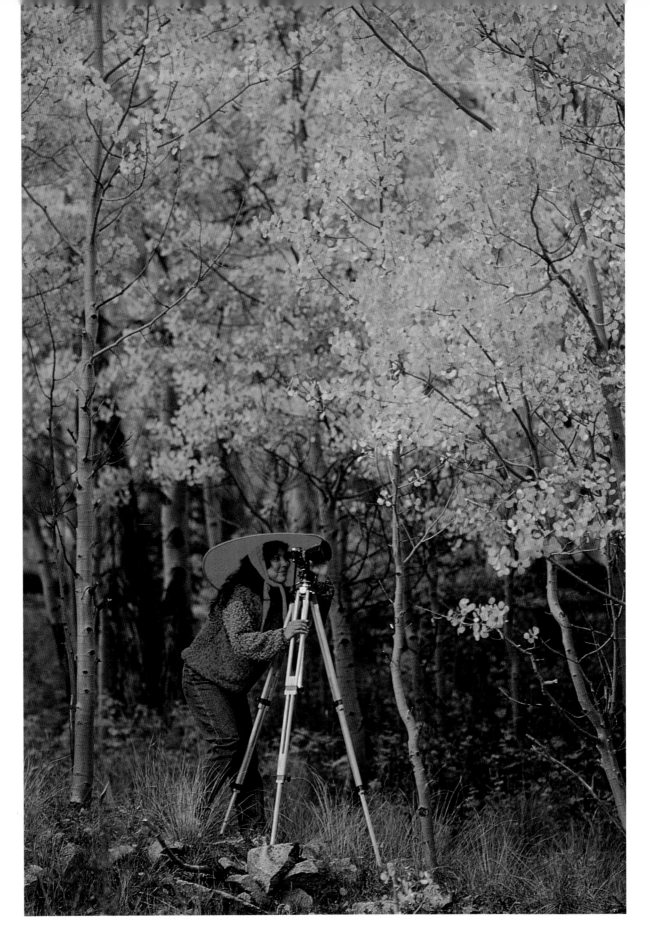

Index